'The heart has its reasons
which reason knows nothing of.'

Blaise Pascal

The Book of Hearts

The Book of Hearts

Francesca Gavin

Laurence King Publishing

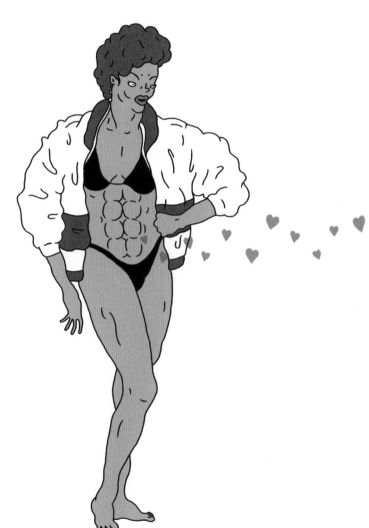

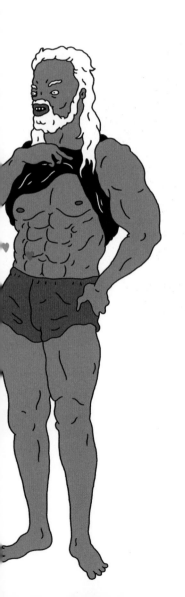

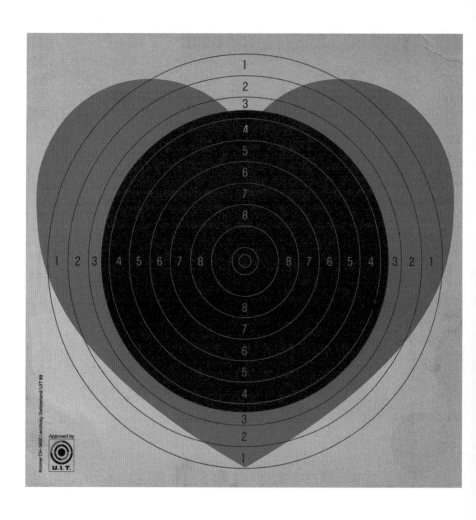

Above: Patrick Thomas,
Heart/Target, 2013.

What is a Heart?

What is a heart? A symbol? An organ? A metaphor? The heart has been an object of fascination since people first became aware of the thing beating in their chests. This book examines the breadth of visual interpretations of this symbol. Although there have been books about the history the heart, there have been none that focus on its depiction.

The first image of the heart was in a picture of a woolly mammoth on a wall of the Pindal Cave in Spain, created around 10,000 BC. The prehistoric painting depicts the animal with a red heart-shaped spot in the centre of its body.

The more traditional heart shape we know today probably evolved from the image of an ivy leaf – a plant that represented sensuality and immortality in ancient Greece. The indented heart shape was then really established in the fourteenth century. The symbol was also used in over 160 trademarks for paper manufacturers, developing from stylized leaves. For centuries, the symbol and word were intertwined with ideas of passion and love. By the nineteenth century the heart had became a cliché – only reinvented in the 1960s and 1970s, when it began to be used in pop cultural imagery.

This book of hearts highlights how a universal symbol can be creatively interpreted and constantly reinvented. It captures the heart's continuing popularity, touching on what makes the history of the shape so engaging – from the guts and gore of the Aztecs and the Cult of the Sacred Heart, to the invention of the Valentine and sailors' heart tattoos. Above all, the artwork here proves why the heart has been an enduring icon of love.

Left: Brian Roettinger, *Courier*, 2013.

Right: Andrew Woodhead, *Break Free*, 2011. Print design for Denim Gallery Biarritz.

Below: Ben Branagan, *Peaceampersandlove*, 2010. Produced for Surburban Bliss Clothing.

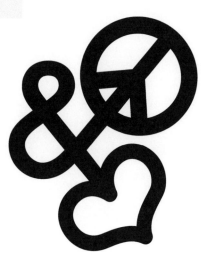

8

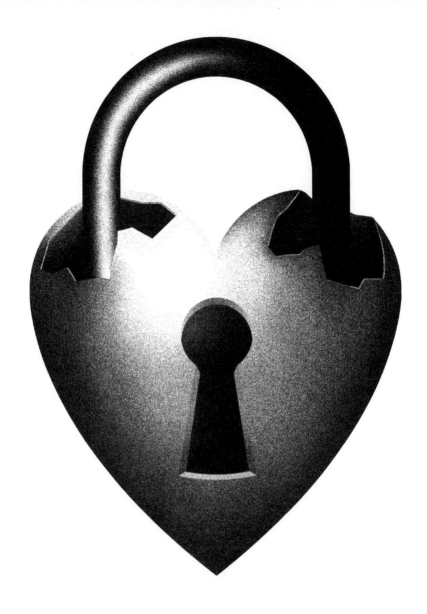

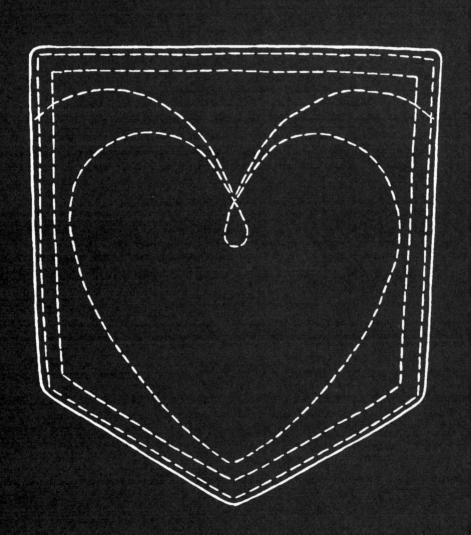

Left: Christian Petersen, *Heartpocket*, from the fanzine *Love*, 2000–2002.

Right Annie Morris, *Please Love Me*, 2013.

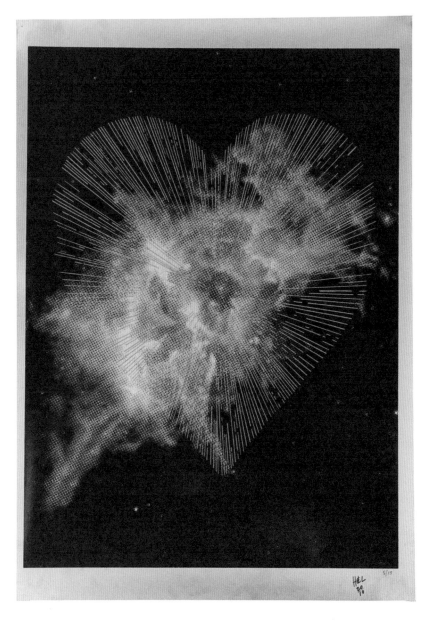

HeL
20/20

5/15

12

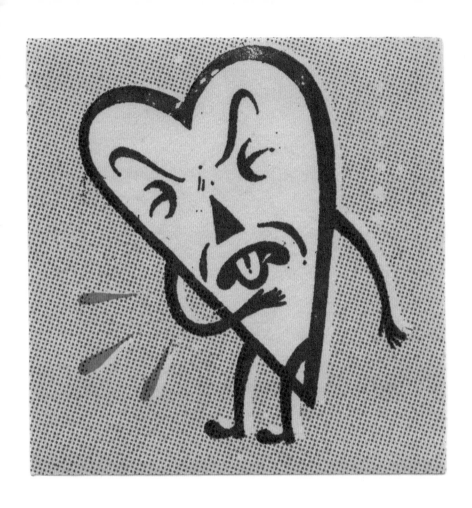

Above: Gary Taxali,
Yucky Heart, 2010.

Left: Hellicar & Lewis,
The Speed of Love,
2010. Commissioned by
Darkroom for their 'Love
and Haiti' exhibition.

Right: Jimmy Turrell, *Heart*, 2013.

Below: Jimmy Turrell, *Glance*, 2013.

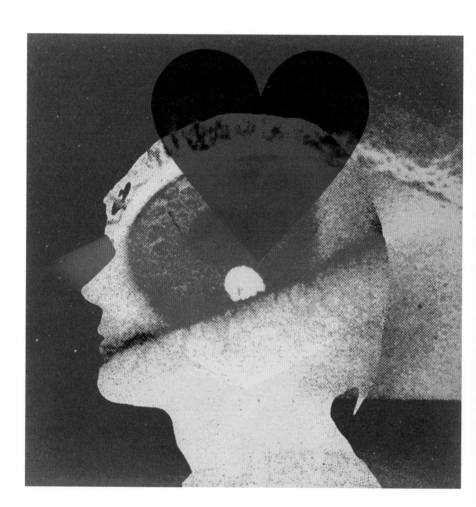

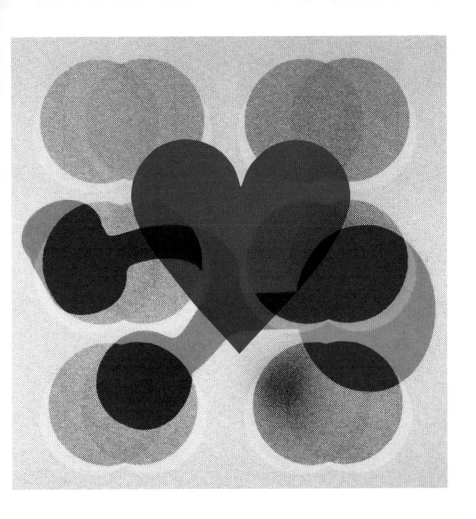

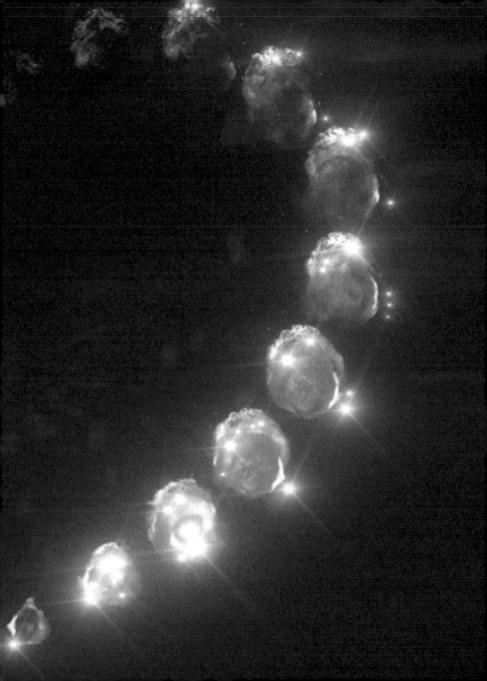

Previous pages:
Ian James Marshall,
Berkley Blooms (still),
2011.

Right: Patternity, *Heart*,
2011.

Below: Zakee Shariff,
Peaceloveheart Rainbow,
2011.

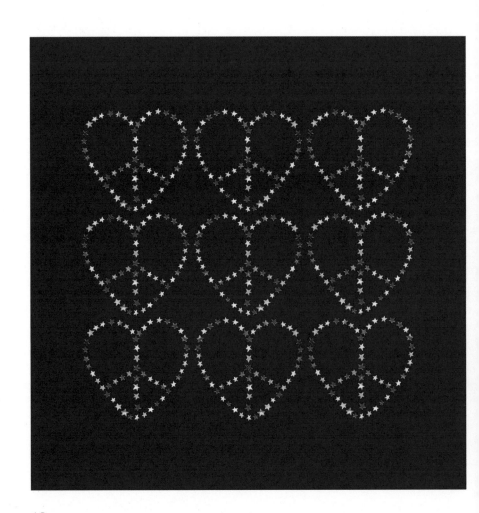

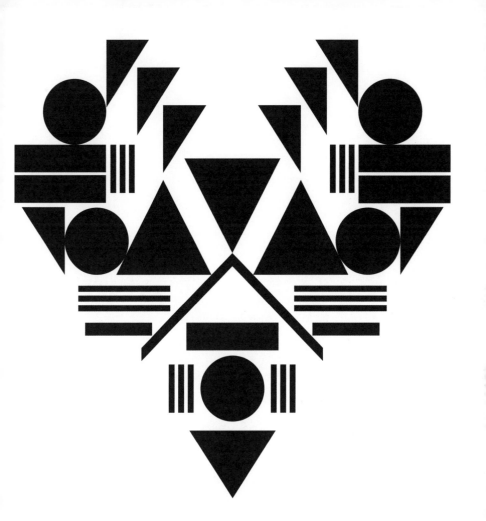

Left: Marta Cerdà
Alimbau, *B&W Are
Not Colors*, 2011.

Right: Théo Gennitsakis,
Coeur, 2010.

Below: Kaws,
Permanent Love,
2010.

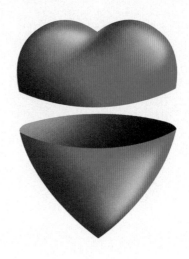

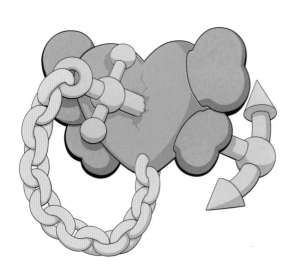

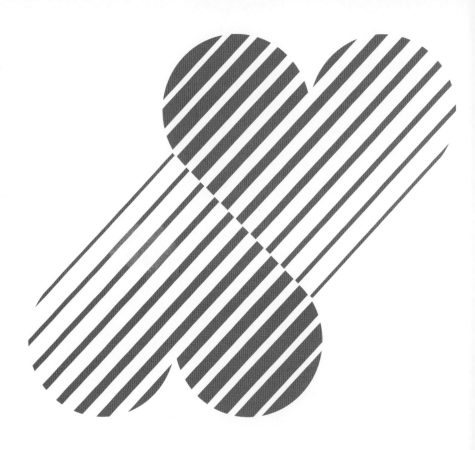

Above: Duane Dalton,
Gradient Hearts, 2012.

Right: Kate Moross,
Heart Print, 2009.

Ancient Egypt

In ancient Egypt the heart was perceived as the centre of the body, religion and the soul. The heart had multiple meanings, just as it does today. The word *ib* stood for the heart soul, and *haty* for the heart organ.

In a culture where language and meaning were made up of images and symbols, the visual representation of the heart had specific resonance. It was depicted as a vessel with an open top and wing-like handles on each side. It was seen as a container or store that held the blood of the individual and housed that person's spiritual centre. The heart was also represented as a scarab beetle.

The heart has a central role in the Egyptian Book of the Dead, or guide to the afterlife. The dead were said to enter 'the hall of two truths', where they faced a panel of gods. Here the heart was placed on a scale and weighed against the 'feather of truth'. If the heart was heavier than the feather, it indicated a sober mind and self-control – the path to eternal life. If the heart was lighter, it would be eaten by Ammit, the eater of the dead.

When a body was mummified, most of its organs were removed and often preserved in canopic jars; the heart, since it was seen as the centre of the body, was the only organ always to be replaced in the body after it had been embalmed. It was vital that the heart was not damaged. A scarab was placed with the dead at burial sites as a spare, in case anything went wrong with the real heart. Metaphorically, Egyptian ideas of the heart seem to foreshadow many contemporary concepts. The Egyptian heart embodied love, loyalty, fertility and emotion.

Right: Stephan Doitschinoff (aka Calma), *O_Coracao*, 2013.

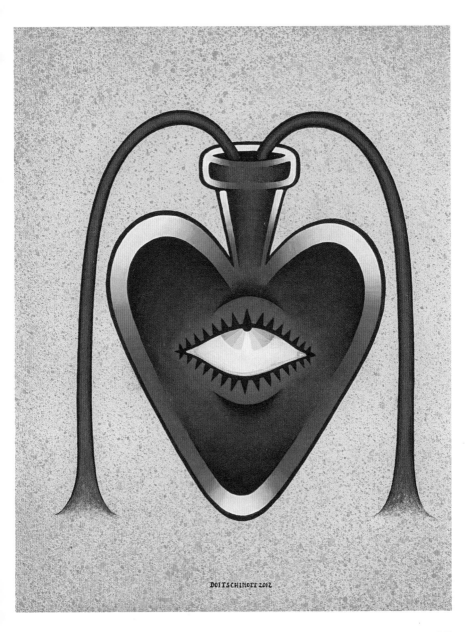

DOITSCHINOFF 2012

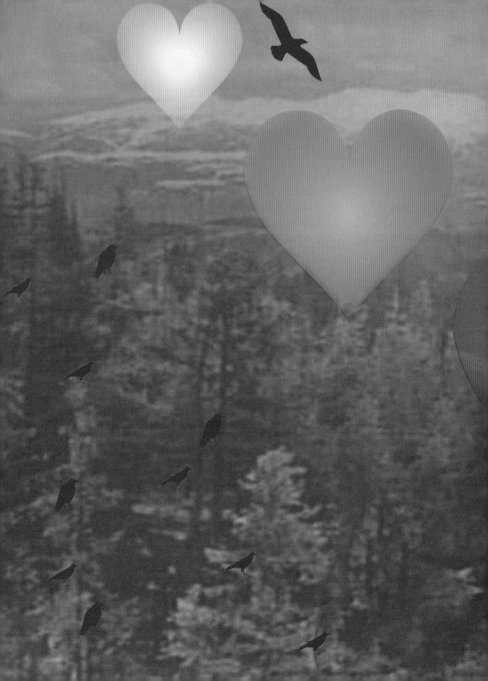

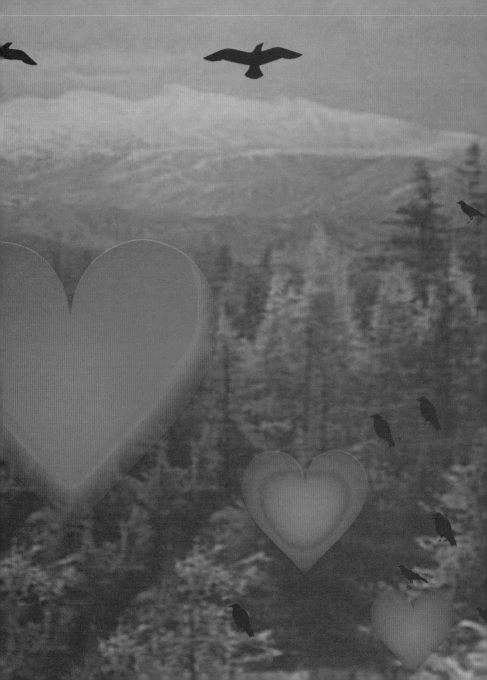

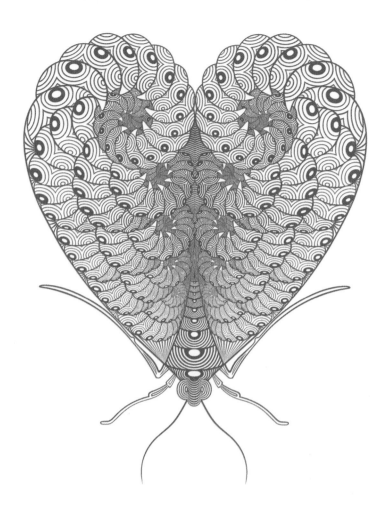

Previous pages:
Cécile B. Evans,
KCTV Hearts, 2013.

Above: Yehrin Tong,
Moth to a Flame, 2013.

Right: Paul McDevitt,
26 February 2013.

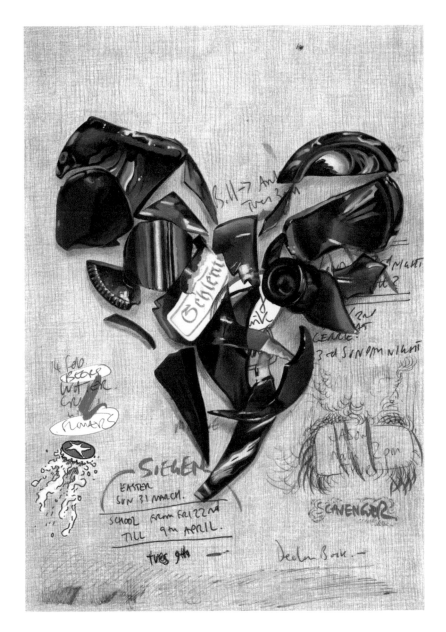

29

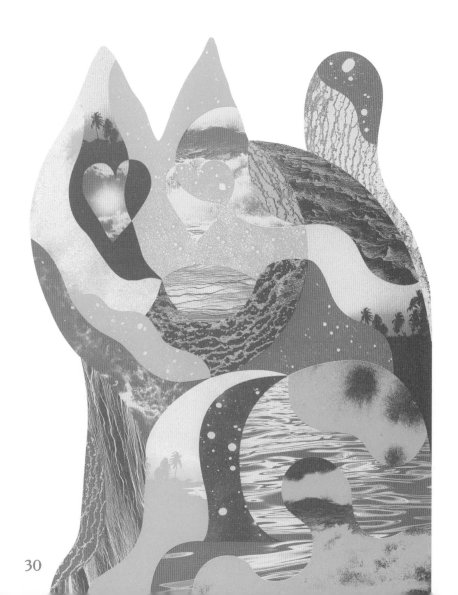

Above: Kenji Hirata,
The Infinitive, 2013.

Left:
Antti Uotila, *Cat*, 2013.

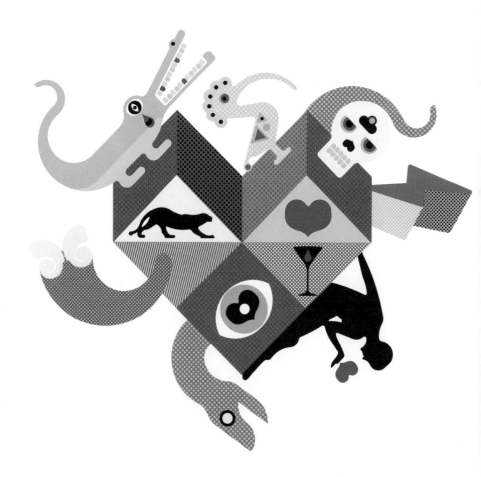

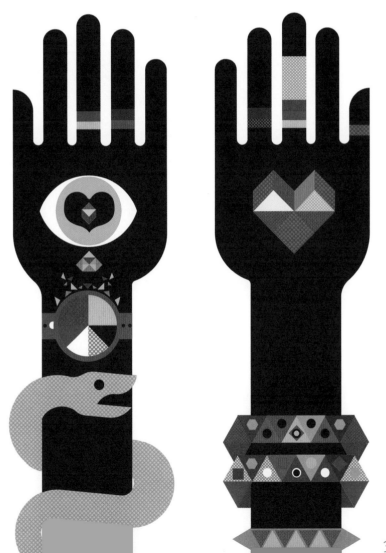

33

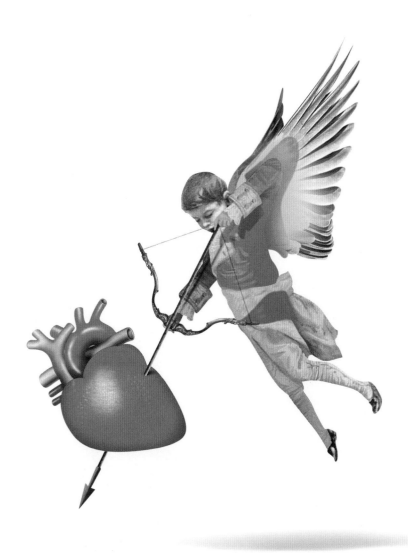

Ancient Greece

The Greek fascination with the heart was rooted in myth. The story of the child Dionysus – the god of pleasure, intoxication and ecstasy – is based around the heart. The Titans kidnapped the child god, killed and dismembered him, then boiled his flesh. They saved his heart to eat last. Athena, the goddess of wisdom, informed the father of the gods, Zeus, who then destroyed the Titans with lightning bolts. Dionysus was reborn from the uneaten heart. The story established the heart as the source of life, and Dionysus as the forefather of culture.

In Greek culture, Aphrodite and Eros represented divine love. Yet the heart was not present in these romantic myths. Instead, the phallus was the focus for the erotic – often represented by the wild, animalistic Pan.

The Greek philosopher Aristotle saw the heart as an inner fire and the origin of life. All nerves led here. Emotions started here, and were in fact purely physical responses. The soul guided the body from its location within the heart. To Aristotle the relationship between heart and soul was also a metaphor for the structure of the body politic and life.

Plato, in contrast, argued that the heart was the rational centre of man, while the soul was located in the head. Sex and the erotic were legitimized under this ideal. These contrasting beliefs of how the body functioned had a huge influence on how people envisaged the heart, and influenced artists for centuries to come.

Left: Brett Ryder, *Cupid,* 2011. One of a set illustrating Sandi Toksvig's regular column for the *Sunday Telegraph*.

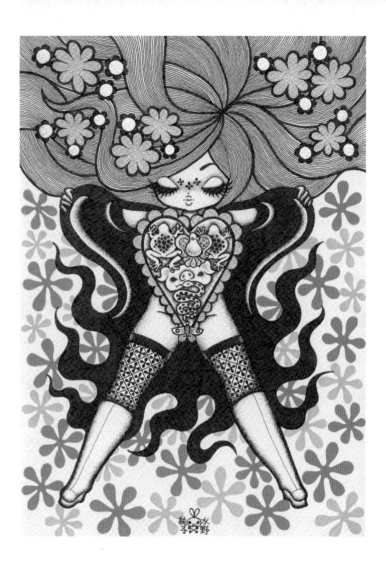

Above: Junko Mizuno,
Fire Bird, 2008.

Right: Steph von
Reiswitz, *Vinaigrette*,
2013.

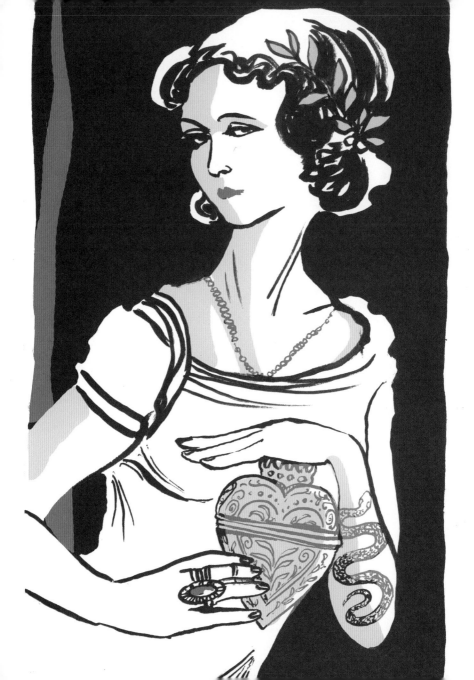

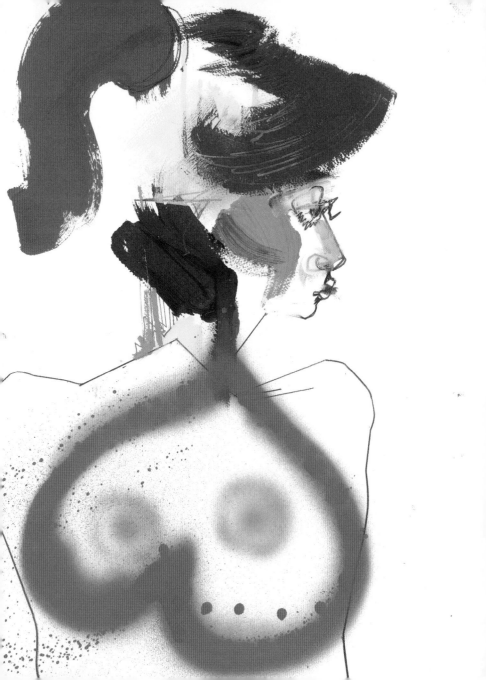

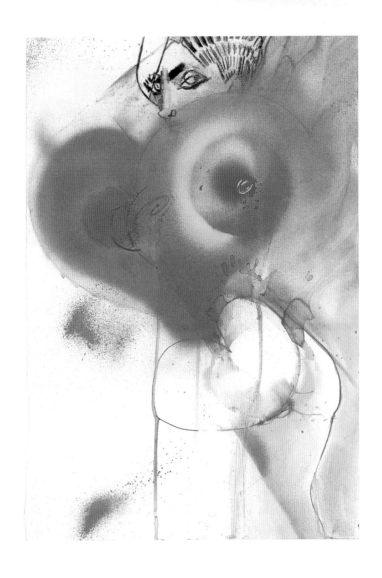

Left: Julie Verhoeven,
Neckline, Sweetheart,
2013.

Above: Julie Verhoeven,
Heart Attack, 2013.

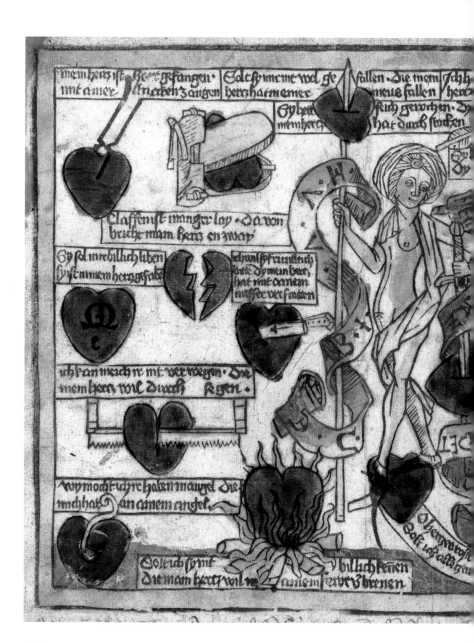

mein hertz ist hertz gefangen·
mit einer mit neben zangen

Solt sy mir wol gefallen·Die mein
hertz hat in einer meins fallen

ich h
herc

Gy het
mein hertz

such geworffen·D
hat durch stecken

Claffen ist manger lay·Da von
bricht man hertz en zway

Gy sol ir billich liben
sy ist in mein hertz gesch

ich wil sy Freuntlich
pitte dy man bett
hat mit dannen
müsse verschniten

ich kan mich ic mit verwegen·Die
mein hertz wil durch segen·

wy macht ich re halen mangel·Die
mich hat an einem angel·

Solich syn
die man hertz wil

billich scheen
an einem fewer v brenen

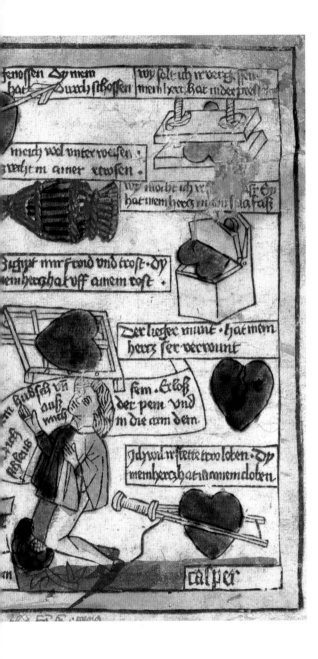

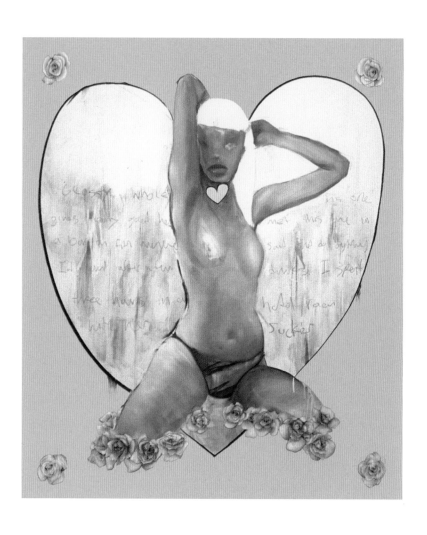

Above: Antony Micallef,
Heart Shaped Girl, 2002.

Right: Yinka Shonibare,
Love Hurts, 2011.

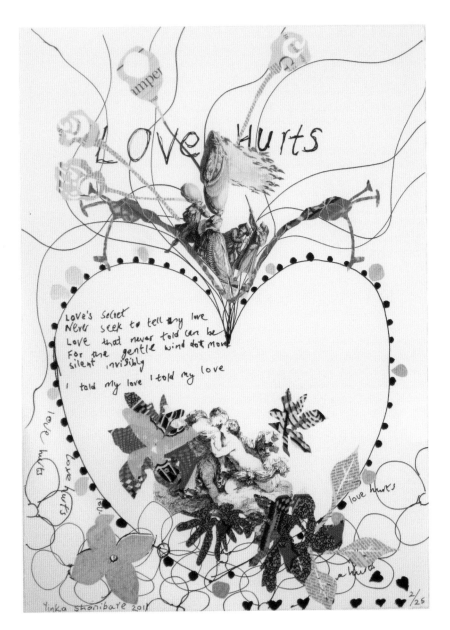

Love Hurts

Love's Secret
Never seek to tell my love
Love that never told can be
For the gentle wind dot move
silent invisibly

I told my love I told my love

love hurts

love hurts

love hurts

love hurts

Yinka Shonibare 2011

2/25

43

Christian Hearts

The Bible is one of the most heart-obsessed books ever written. The word 'heart' is used between 800 and 1,000 times – depending on who is counting. The ancient Hebrew *lev* (heart) meant the emotional inner life, personality, understanding and collective mind of society.

St Augustine of Hippo was central to the dominance of the heart in Christian iconography. His autobiographical book, *Confessions,* written circa 400 AD, describes the heart as the way for man to know God. Christianity in the Middle Ages was a physical experience. The body was a vehicle for emotion and revelation. Symbols of love and eroticism were transferred to the love of Jesus. The arrows of Eros were transformed into the spears in Christ's side. The heart became the symbol for religious passion and love, compassion and the suffering of God on behalf of man.

The symbol of Christ's heart was widespread in the late Middle Ages in altarpieces, illustrations and paintings. Images of the heart did not employ the stylized form we know today; it was depicted as an acorn-like shape with an opening at the top, like a bottle.

The Virgin Mary's heart was often represented as studded with arrows and surrounded by wreaths of flowers. The flaming heart, burning with devotion, was first depicted around 1500. Broken or wounded hearts became objects of piety. In the eighteenth and nineteenth centuries, nuns made numerous heart-shaped devotional objects. These included picture frames, oil lamps, medallions, inkwells, matchboxes, holy water stoups (basins) and reliquaries. However, the heart symbol became increasingly kitsch and began to lose its cultural potency.

Right: *Allegory of a bad conscience: The state of a man who thinks seriously about the bad state of his conscience, and who begins to be affected by it*, 19th century.

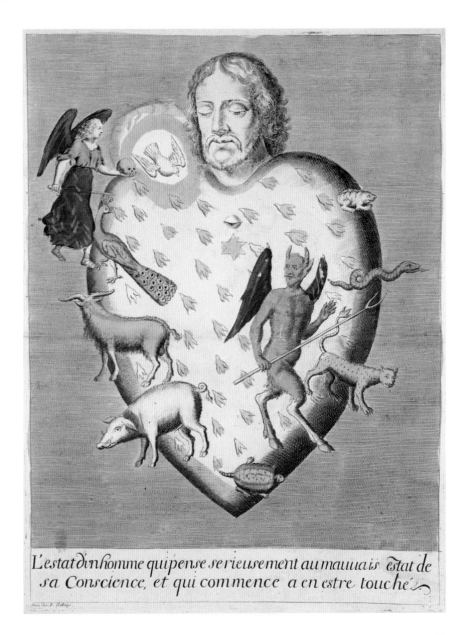

L'estat d'un homme qui pense serieusement au mauuais estat de
sa Conscience, et qui commence a en estre touché

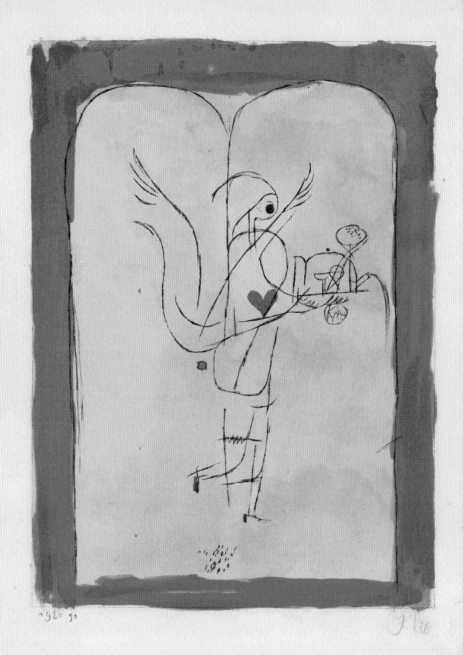

1920 91

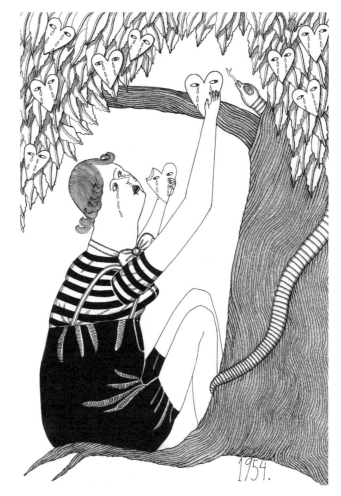

Left: Paul Klee,
*A guardian angel
serves a small breakfast*,
from the yearbook for
1920.

Right: Emma Rendel,
youandmeonholiday1954,
2013.

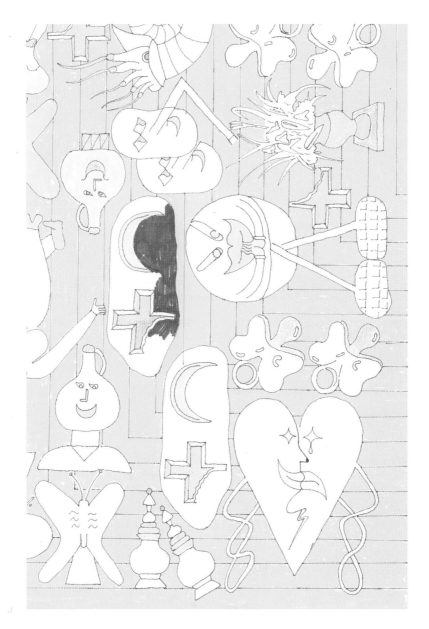

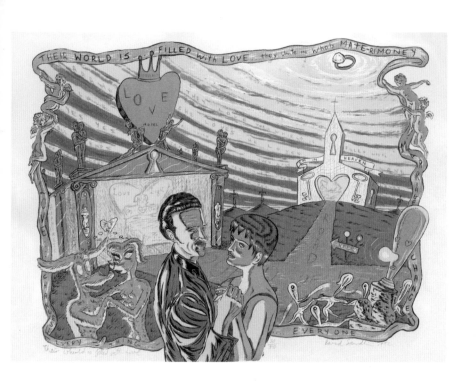

Above: David Sandlin,
Holy Mate-rimoney, 1993.

Left: Keegan McHargue,
Untitled (Sampler), 2010.

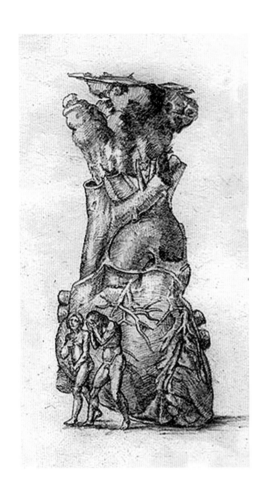

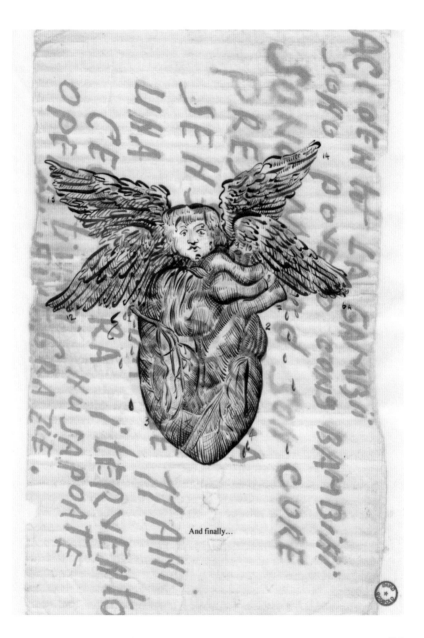

And finally…

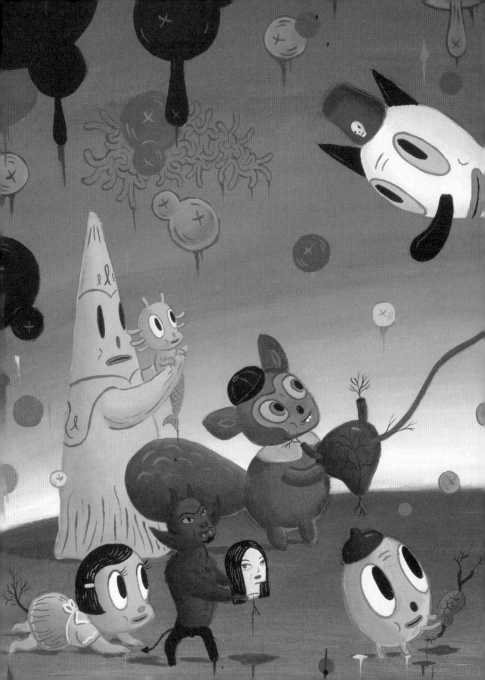

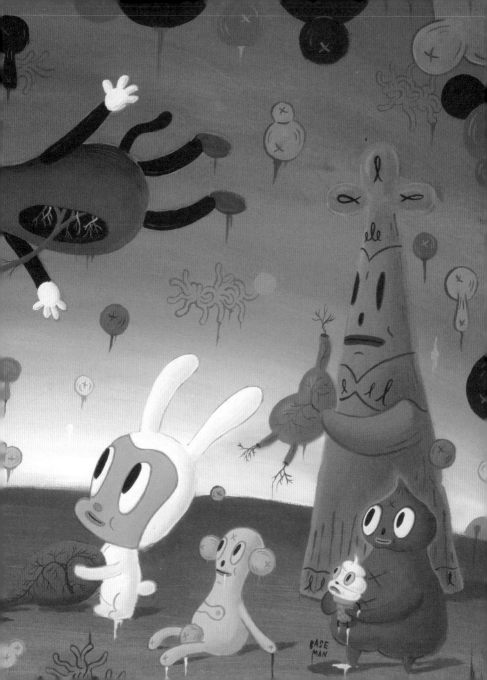

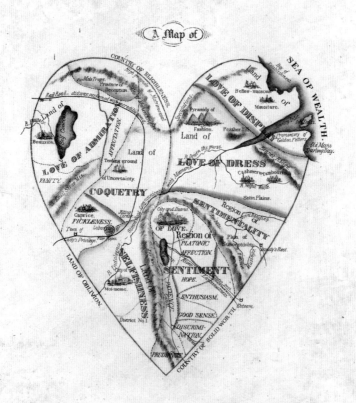

A Map of

THE OPEN COUNTRY OF

WOMAN'S HEART.

Exhibiting its internal communications, and the facilities and dangers to Travellers therein.

BY A LADY.

Lith. of D. W. Kellogg & Co. Hartford, Conn.

The Age of Chivalry

If you want to find a moment when the heart was separated from the physical and transformed into a romantic ideal, look at the Middle Ages – when the heart became a romantic pin-up. During the twelfth and thirteenth centuries, a new wave of creative expression emerged, which included a redefinition of femininity, new musical forms and literature. Courtly love was based around highly ritualized poetic scenarios where devoted lovers could not be together. Consummation was not the focus. This model of unrequited love was established by Chrétien de Troyes' Arthurian legends and the story of Tristan and Isolde.

During the Crusades, when distance was a strong feature in relationships, the heart became a metaphor for the emotional. The idea of the exchange of hearts was used as an expression of mutual love. Lovers joining as one became the focus of religious and secular literature. Idealized emotional transactions were created as a new approach to human nature. The Church was not a fan of chivalric love, as it took the focus away from God. Nonetheless, at this time it promoted the ideal of faithful marriage. Contemporary romantic love is still based on these constructions. The wildness of eroticism and physical passion were replaced with ideas of fidelity and noble emotion.

Visually, the symbol of the heart was not often used during this period. The heart was more a feature of poetic language and lyrics. The amorous visual motifs of the time were flowers, birds, roses and romantic couples. The heart shape was yet to become visual shorthand for love.

Left: *The Open Country of Woman's Heart,* c. 1833–1842.

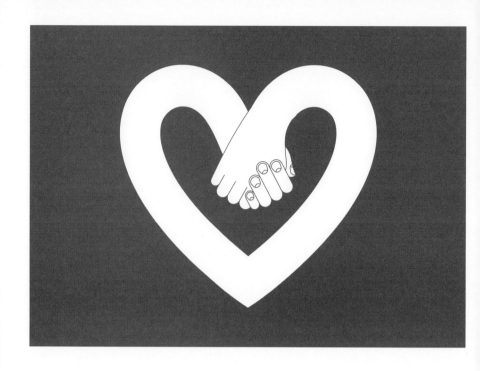

Above: Craig & Karl,
2 Become 1, 2010.

Right: James Joyce,
Untitled, 2010.

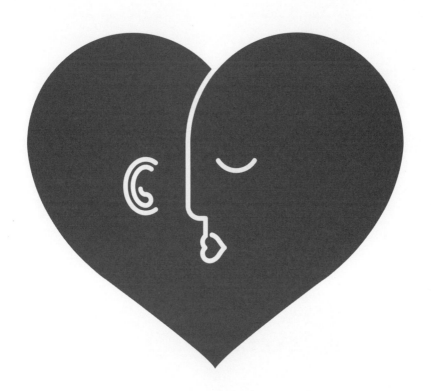

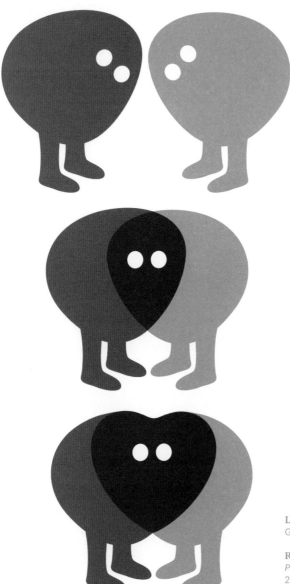

Left: Geneviève Gauckler, *Heart*, 2012.

Right: Noma Bar, *Protect Your Heart*, 2012. Published in the *Guardian*.

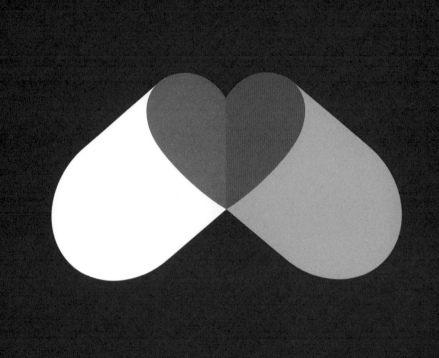

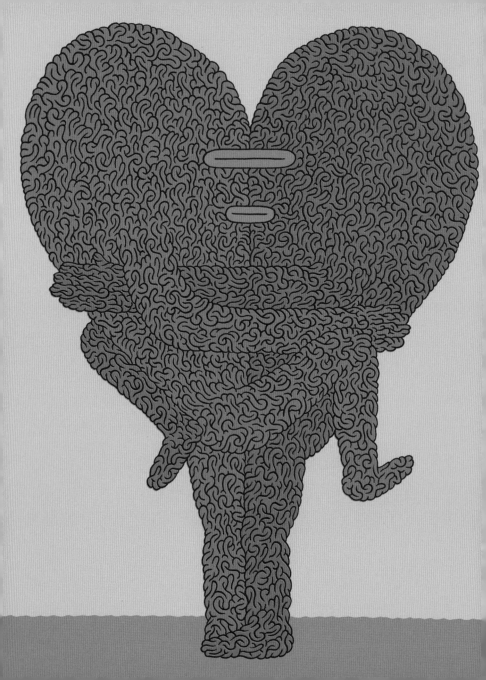

Below: Emily Forgot,
Ribbon Heart, 2012.

Following pages:
Rob Ryan, *All of the
Words in the World*, 2010.
Created for the British
Heart Foundation.

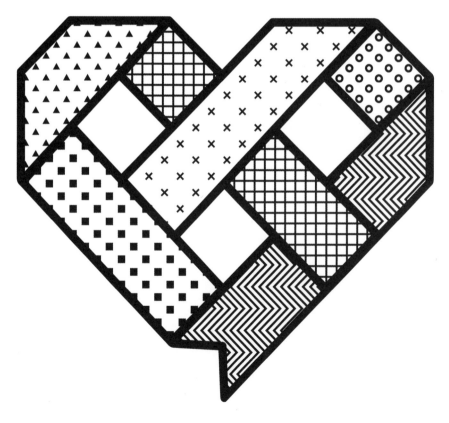

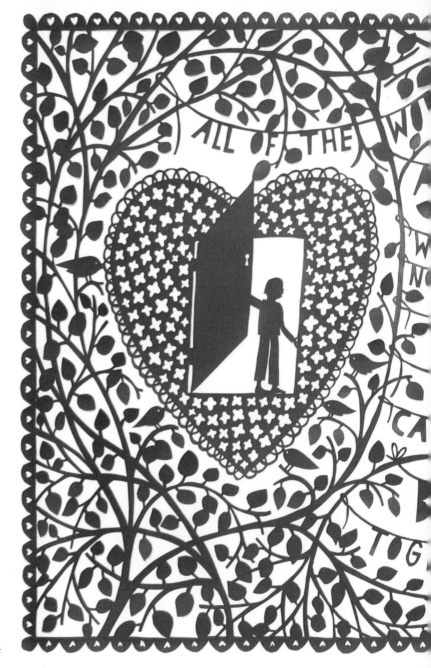

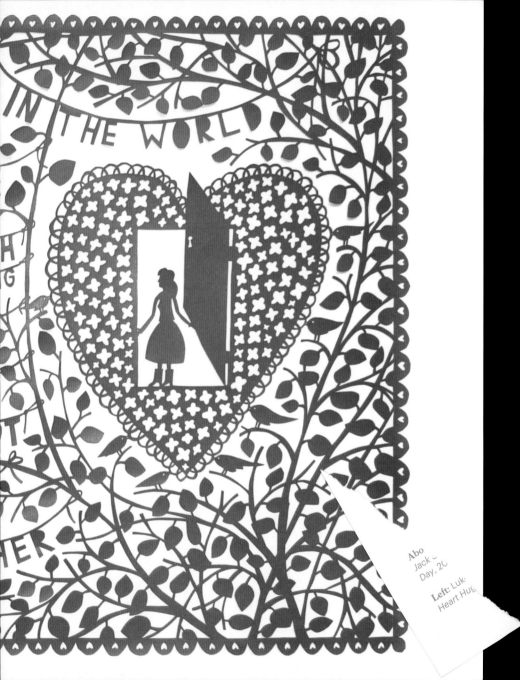

Cult of the Sacred Heart

The worship of the heart began in the High Middle Ages, growing out of ancient ideas of blood and sacrifice. The Cult of the Sacred Heart emerged from the visions of various female saints between the twelfth and fourteenth centuries. These women saw Christ and sucked on his wounds or swapped their own heart for his. There was a sublimated undercurrent of sex, penetration and absorption within the description of these manifestations. This brief northern European cult then exploded in the seventeenth century.

The woman to take heart worship to a whole other level was the French saint Marguerite-Marie Alacoque (1647–1690). She belonged to a convent founded by St François de Sales, whose coat of arms was notably a fusion of the Sacred Heart of Jesus and the Immaculate Heart of Mary. On 27 December 1673, she had a vision of the Sacred Heart, shining, transparent and surrounded by a crown of thorns. She saw Christ remove her heart, place it within his own, set it alight and put it back in her body.

After this experience, in a twisted, somewhat revolting version of the Eucharist, Alacoque would heal the ill by kissing their sores and ulcers, or by eating their vomit and pus. Her followers used the heart symbol as a form of spiritual propaganda; painted hearts were circulated as flyers. Jesuits, aware of the mass appeal of the symbol, spread the cult. The Sacred Heart was championed – in contrast to the Protestant's focus on the simplified heart shape. The passionate, visceral heart personified the sensorial end of the Catholic Church.

Right: Alex Binnie,
Heart, 2008.

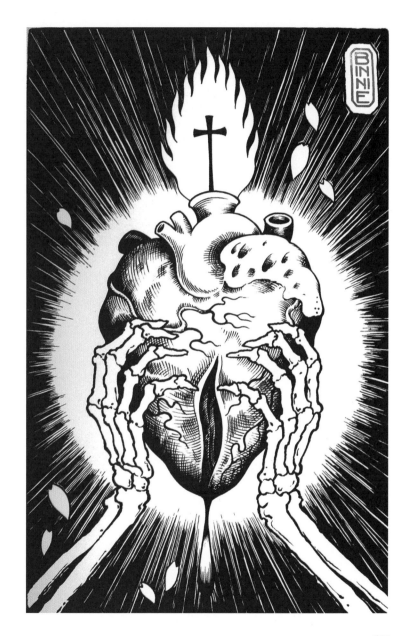

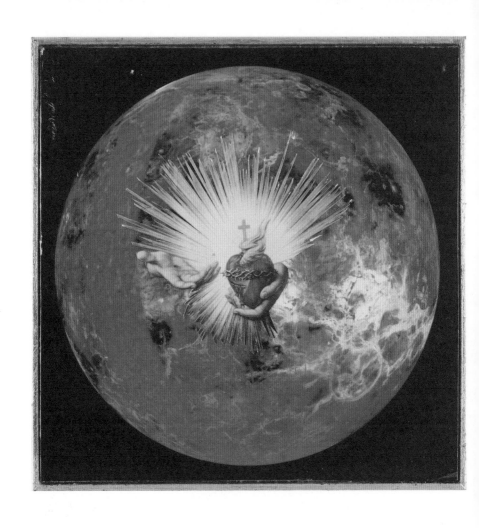

Above and right:
Aleksandra Mir, *The Space Age Collages*, 2009.

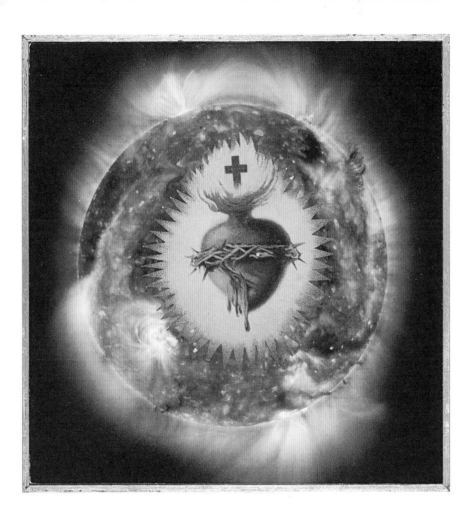

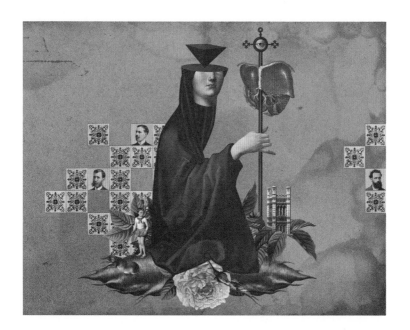

Above: Randy Mora,
Torre Bianca, 2010.

Right: Peter de Wale,
Christ Child in a Heart,
1470.

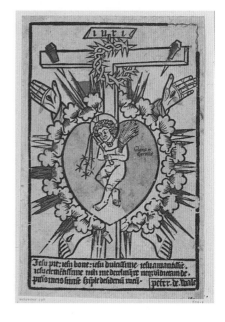

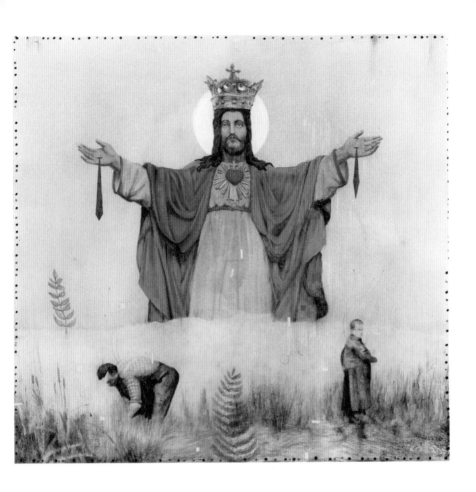

Above: Marco Wagner,
Heimat Gerne, 2011.

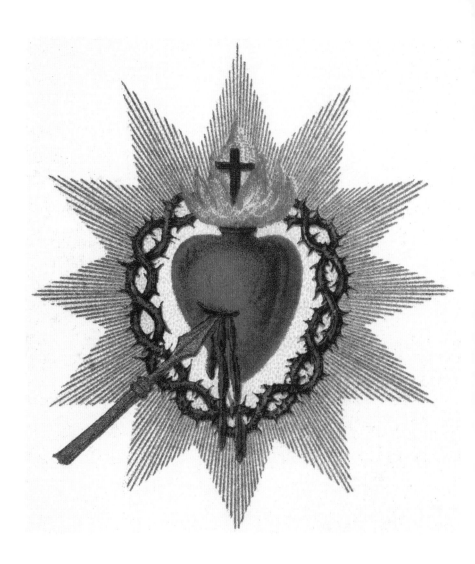

Left: *Sacred Heart,* German, c. 1880.

Right: Angelique Houtkamp, *Love,* 2010.

Below: Robert Rubbish, *OH MY CROZONE,* 2012.

Aztecs and Mexico

The Aztecs have a rather gruesome reputation when it comes to the heart. The last major independent culture of Mesoamerica thrived from the thirteenth to the fifteenth century. The Aztecs believed in the imminence of the end of the world, which could only be abated by regular human sacrifice. To be chosen as a sacrificial victim was considered an honour and a path to eternal life. Living victims were placed on slabs at the pinnacle of Aztec pyramids. A sacrificial priest would then cut their chests open with a flint knife, remove their hearts with his bare hands and offer it to the sun gods.

When the Spanish Conquistadors invaded in the sixteenth century, their first duty was to erase Aztec culture. When they arrived, almost 15,000 Aztecs were sacrificed annually. With the blessing of the Catholic Church, the Spanish massacred the Aztecs as heretics, which decimated the population and obliterated the culture's literature and history.

The Church later tried to assimilate the Aztec fascination with heart iconography and the Catholic Sacred Heart. Colonial painters in native villages would mass-produce Baroque Catholic imagery. Hallucinogens were widely used by all levels of Mexican society in the seventeenth century. As a result a hyper-decorative religious aesthetic began to develop.

After the Mexican War of Independence of 1810 to 1821, the religious kitsch of the country's visual culture began to define the nation's identity. The heart became an icon of national courage and was used as a symbol of independence in the 1910–1917 revolution. The connection between the political, the religious and the heart in Mexican visual culture continues to this day.

Left: Javier Rodriguez
Garcia / Lobulo Design,
Do Epic Shit, 2013.

Left: Craig Robson,
Angel of Death, 2012.

Above: Craig Robson,
Mystery, 2013.

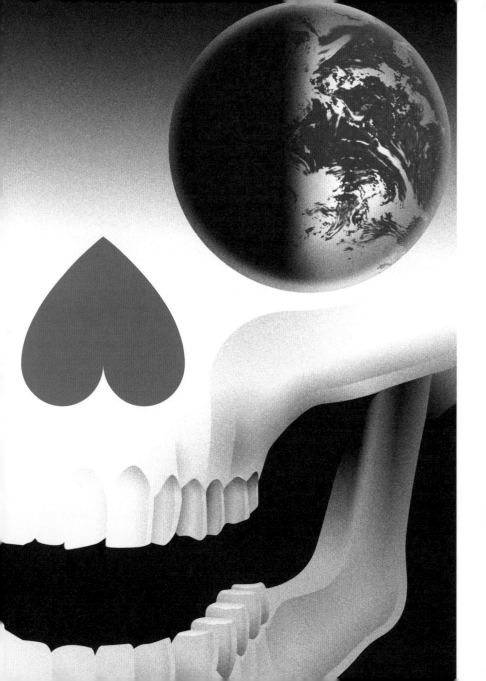

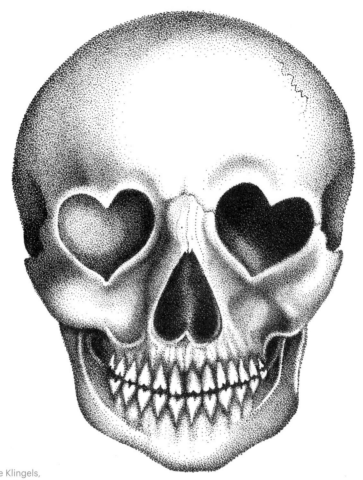

Right: Izzie Klingels,
Love Forever, 2012.

Left: Jonathan Zawada,
*It Was on Earth that
I Knew Joy*, 2009.
Created for Sixpack
France to promote the
film and exhibition at
Scion Gallery, Culver
City, California.

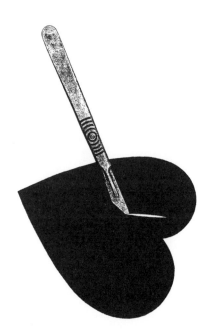

Left: Christian Petersen, *Heartscalpel*, from the fanzine *Love*, 2000–2002.

Right: Jonathan Zawada, *Misericordia*, 2010. Created for Sixpack France.

Below: Donald Urquhart, *I Love Luger*, 2006.

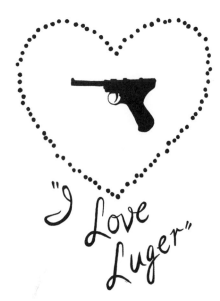

"*I Love Luger*"

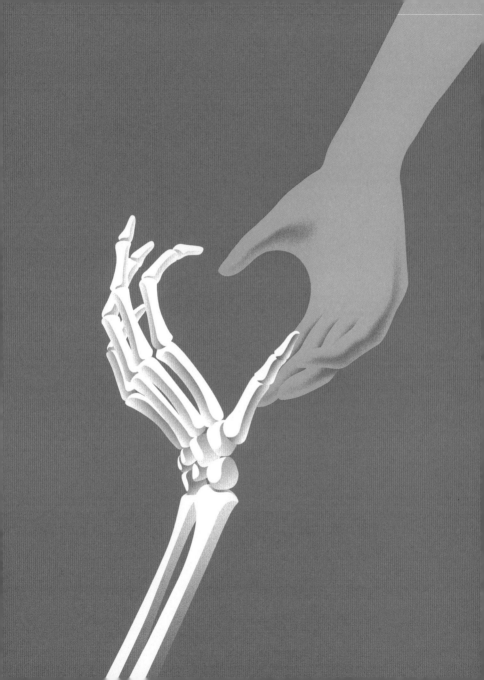

Playing Cards

Playing cards were very influential in disseminating the heart symbol. They were probably invented in China or Korea, before their existence was recorded in Europe in the late fourteenth century. Originally the four card suits were swords, chalices, coins and batons. One argument is that the four suits stood for four socio-politcal estates – swords for the aristocracy, chalices or cups for the clergy, coins for burgers, batons for peasants. This referenced the Holy Grail and the blood of Christ.

The Spanish were the first to modify the design of cards but it was the Germans who made hearts (*Herzen*) a suit. The symbol replaced cups, alongside bells (*Schellen*), leaves (*Grün* or *Laub*) and acorns (*Eicheln*). French decks popularized the heart symbol, which was simpler for manufacturers to create and players to remember.

Cards were given as keepsakes and wedding gifts. The imagery on playing cards in the seventeenth century often focused on education – depicting historical characters, mathematics, geography or grammar. The court cards also began to depict French kings.

Satire and dissent began to appear in card imagery. One popular French deck could be seen as a critique of Henry III. As the third son of Catherine de Medici and Henry II was a transvestite, the King of Hearts was painted as carrying a fan, while in the same deck, the Queen was shown with a sceptre – arguably in control. In England, the ever-furious Queen of Hearts was the central adversary in Lewis Carroll's *Alice's Adventures in Wonderland*. The illogical character of this satirical portrayal of Queen Victoria could be seen as a representation of the unexpected, sometimes violent, aspect of love.

Right: Chris Bianchi, *Untitled Heart*, 2013.

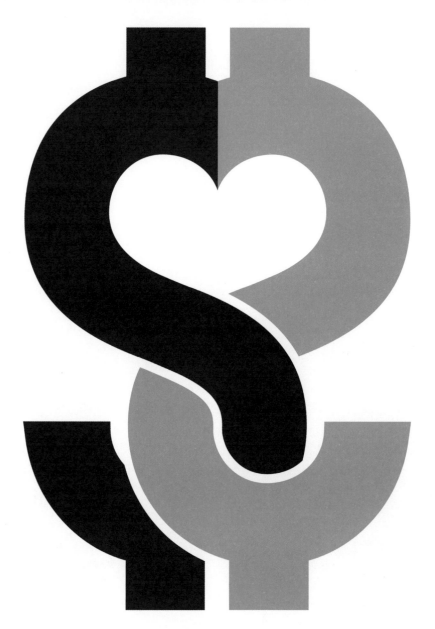

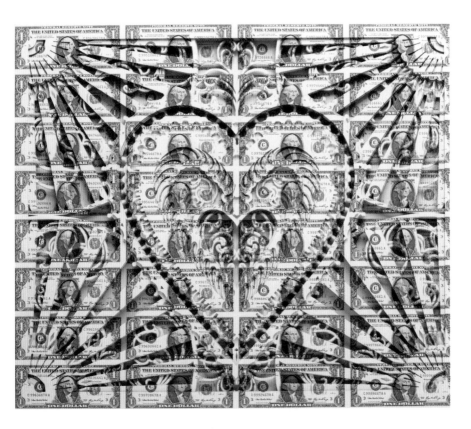

87

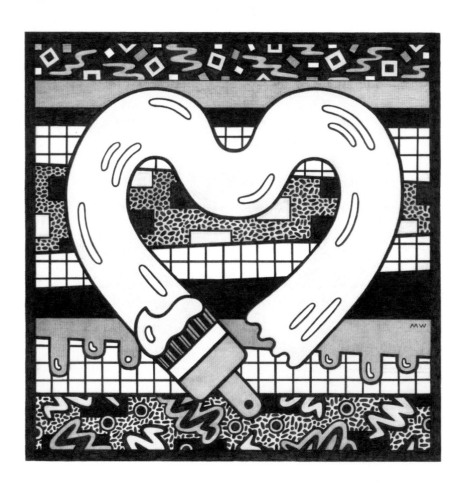

Above: Maya Wild, *Painted Love*, 2013.

Right: Brad Downey, Matthew Murphy and RWO Stone, *My Funny Valentine*, 2010.

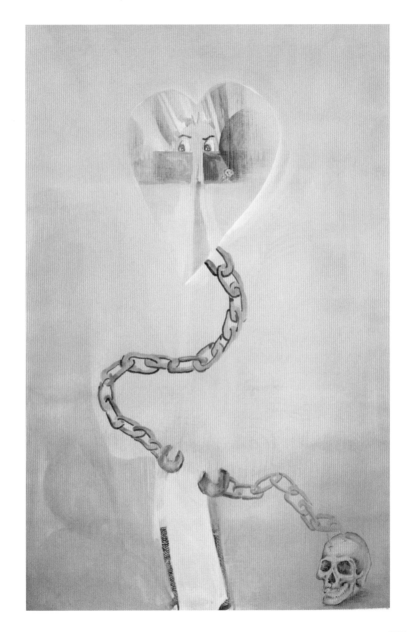

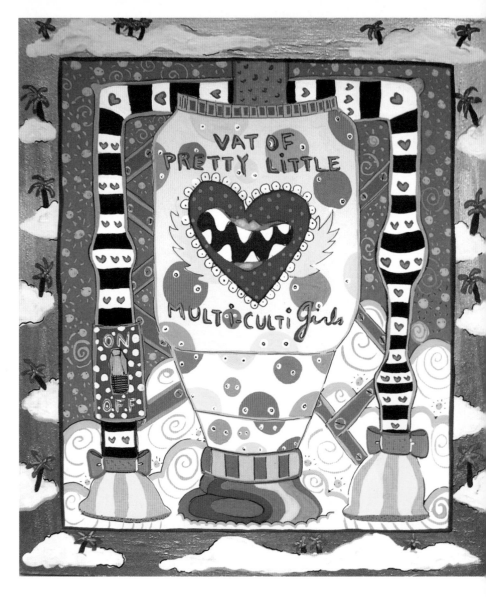

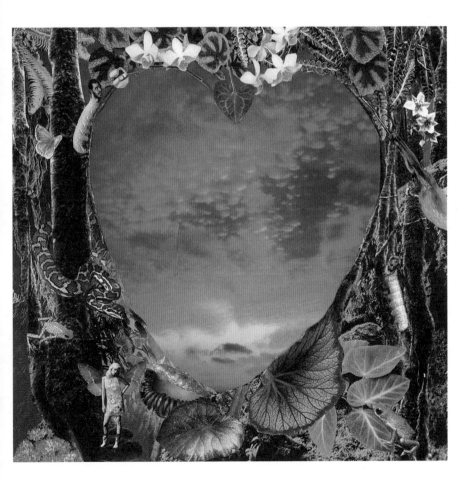

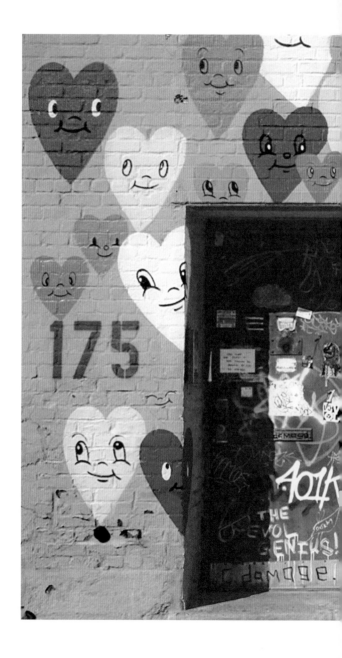

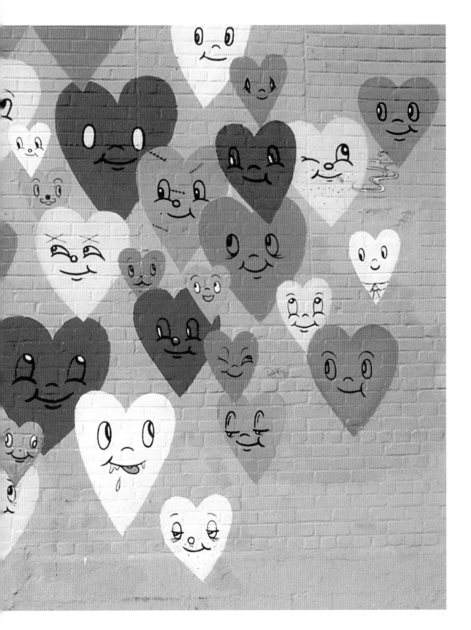

Emblemata

The lasting popularity of the heart symbol owes much to seventeenth-century bestsellers – emblemata. These books were intellectual guides to moral life. Each emblem would be split into three parts – a motto, an illustration of the page's concept, and a descriptive text in verse. The first emblemata book, *Emblematum Liber*, was written by the Italian humanist and juror, Andrea Alciato, and published in 1531. Eighty editions had been printed by the end of the seventeenth century.

It had hundreds of imitators. The first emblemata on love, *Quaeris quid sit amor?* (You want to know what love is?), was published in 1601 with engravings by Jacob II de Gheyn and verse by Daniel Heinsus. It gave birth to a genre – *emblemata amatoria*.

In these books the heart became a conceptual, or in some cases literal, protagonist. The heart was depicted as suffering, surrendering, broken, flaming, winged, as a book, in a brick oven, even with a foreskin. Daniel Cramer's *Emblemata Sacra* presented the heart as a personified character in forty scenarios. Cramer had many imitators, and his hearts were often used in northern European architecture and Lutheran churches. Symbols were a way to sidestep the forbidden nature of imagery under Protestantism.

People would put the emblem prints and page into handmade anthologies in order to create new meanings and interact with the work. They were also used in games of conversation between the sexes. The heart was a perfect symbol for this nuanced culture of symbolism.

Left: FriendsWithYou, *I Heart You*, 2004.

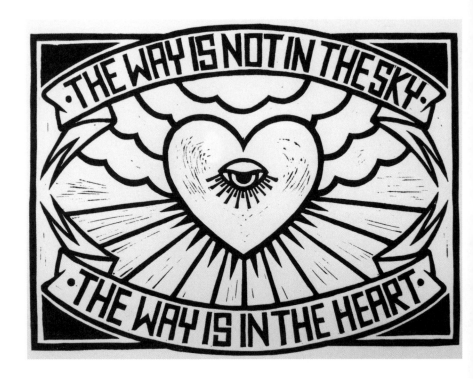

Left: Chris Bourke,
The Way, 2012.

Right: FriendsWithYou,
Protection, 2002.

Below: Craig & Karl,
Love, 2010.

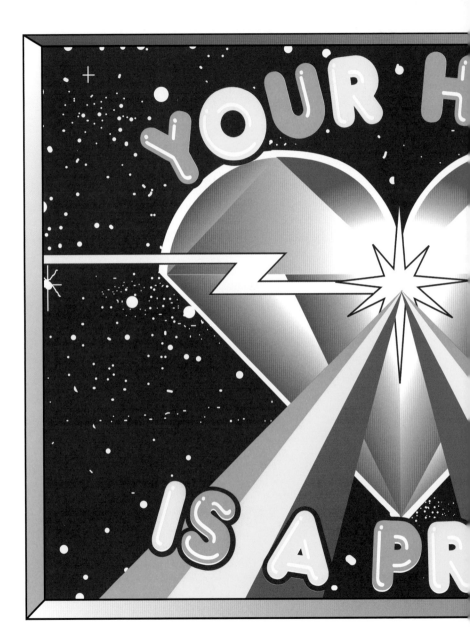

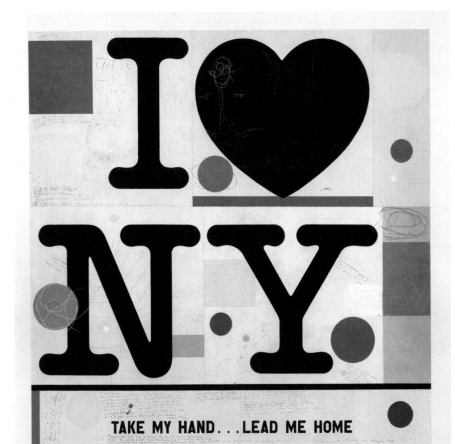

TAKE MY HAND...LEAD ME HOME

Left: David Spiller,
*Take my Hand...Lead
me home,* 2002.

Below: David Spiller,
We can touch the stars,
2009.

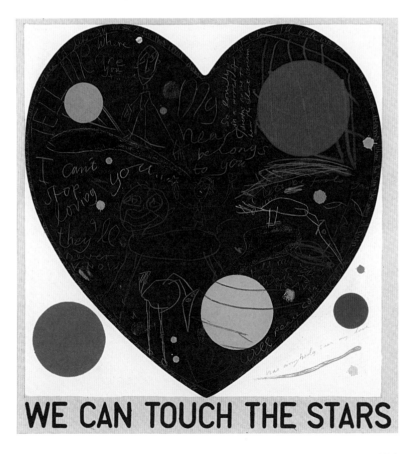

WE CAN TOUCH THE STARS

Above: FriendsWithYou,
I Heart Malfi, 2002.

Right: Nigel Payne,
I Love Tea, 2006.

Opposite:
FriendsWithYou, *Love
Buddy*, 2006.

Valentine's Day

The origins of Valentine's Day have long been debated. The three St Valentines who were martyred seem to have had nothing to do with romanticism or lovers. Instead, the Roman spring fertility rite, Lupercalia, has been sited as a source for Valentine's Day. Held in honour of Faunus, it involved two blood-stained nobleman's sons running naked in the street, whipping all in their path with goat-skin thongs. The relationship to Valentine's Day, however, is probably a coincidence of dates.

The real foundation of Valentine's Day appears to be a line in Geoffrey Chaucer's poem, 'Parlement of Foules' (1382). The poem was written in honour of the engagement of King Richard II and Anne of Bohemia. Chaucer wrote 'For this was on seynt Volantynys day / Whan euery bryd comyth there to chese his make' ['For this was on Saint Valentine's Day, when every bird cometh there to choose his mate.'] If birds paired up in February, it followed suit that people would do the same.

The first Valentine note was written in 1415 by Charles, Duke of Orléans, who sent it to his wife, when he was held in the Tower of London after the Battle of Agincourt. He wrote, 'I am already sick with love, My very gentle Valentine.' After that William Shakespeare, Edmund Spenser and John Donne all wrote poetry about Valentines. Numerous folk traditions emerged around pairing youths on Valentine's Day. The Industrial Revolution then took these folkloric practices and turned them into an industry.

Right: Maya Hayuk, *Untitled*, 2013.

Below: David Saunders,
*The human heart will
beat 2.5 billion times
during one lifetime
(I have skipped a few
times already though)*,
2013.

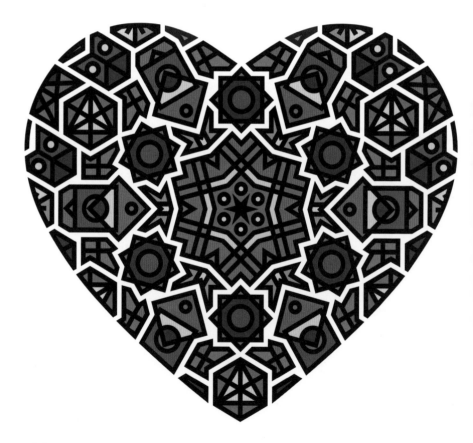

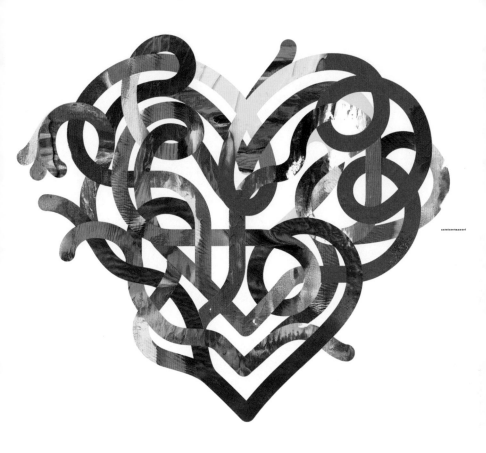

Above: Antoine et Manuel, *Cheries Cheris*, 2008–2009. Poster for gay and lesbian film festival.

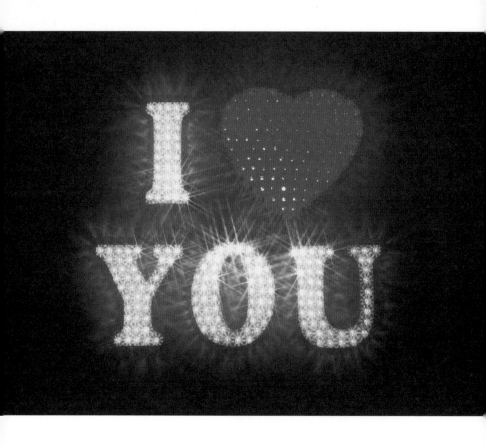

Above: Tim Noble &
Sue Webster, *IY YOU
(I LOVE YOU)*, 2000.
298 coloured UFO
reflector caps, lamps
and holders, Foamex,
aerosol paint, electronic
light sequencer
(12 × 3-channel spell,
fill & shimmer effect).

Right: Tim Noble & Sue
Webster, *fuckingbeautiful*
(snow white version),
2002. 8 neon sections,
transformers.

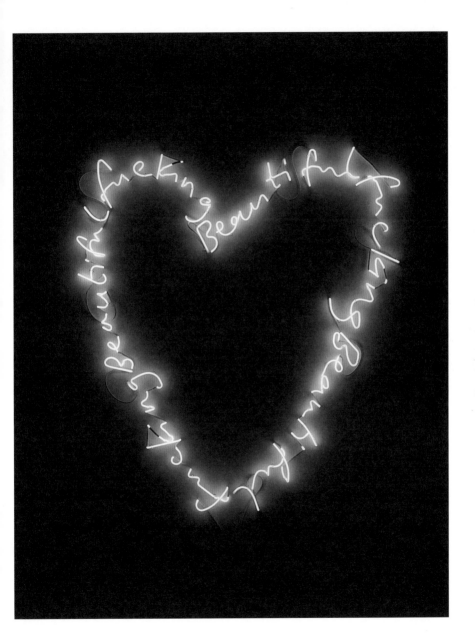

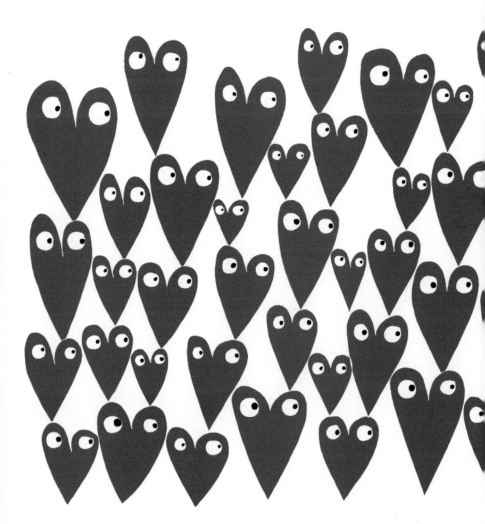

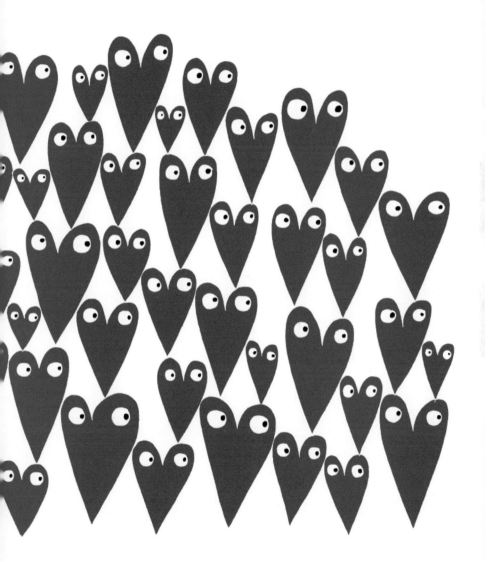

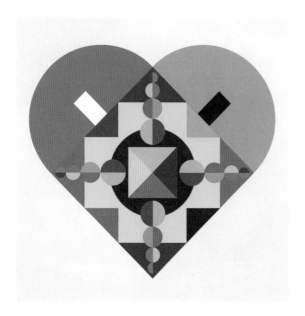

Left: Hvass + Hannibal, *Untitled*, 2013.

Below: Hvass + Hannibal, *Untitled*, 2013.

Right: Hudson Powell, *Floral Tat*, 2013.

Following pages (left): Noma Bar, *Rom Com*, 2012.

Following pages (right): Noma Bar, *Protect Your Heart*, 2012.

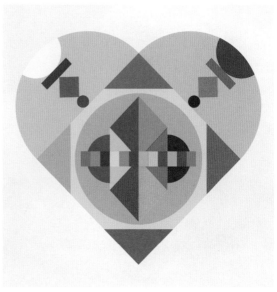

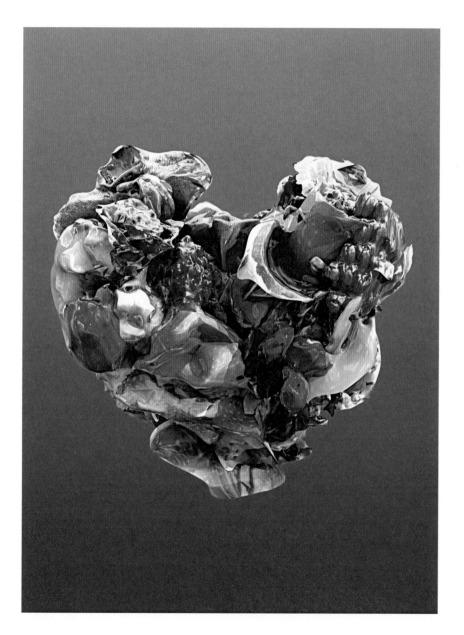

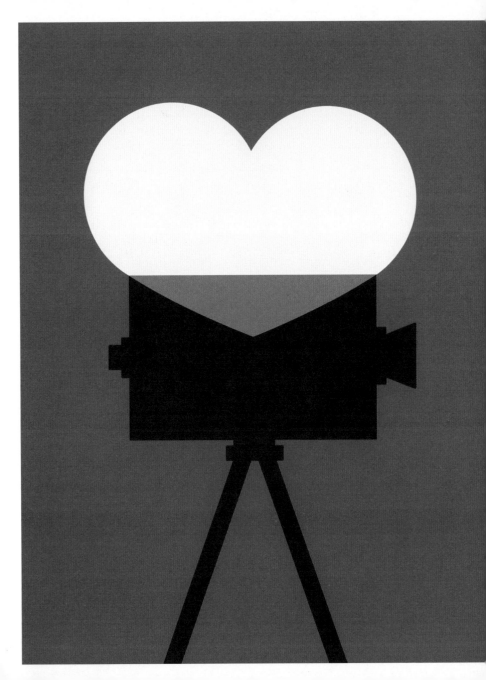

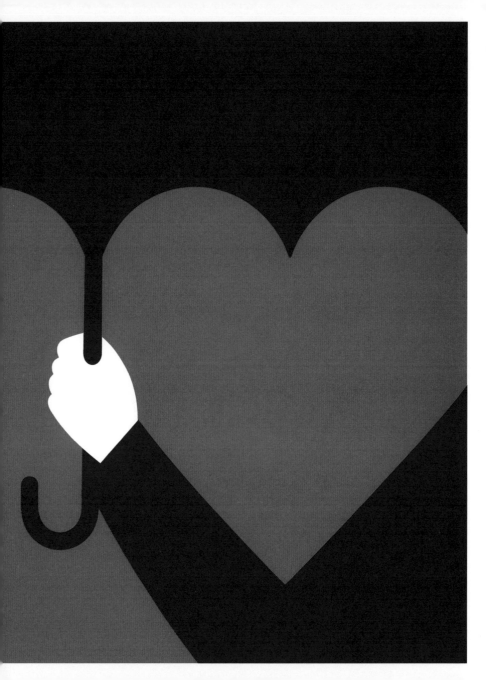

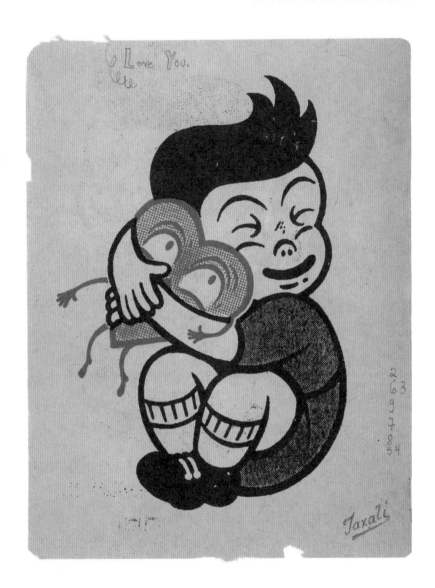

Valentine's Cards

Although the intention may be romantic, the endurance of Valentine's Day reflects the history of industry and capitalism. By the seventeenth century it was customary for men to give women love tokens or decorated letters on this day. By 1760, this had developed into expensive gifts, flowers and sweets.

In the 1780s, printed 'greetings' cards were created in Germany – decorated with imagery such as winged cupids to give on New Year's Day. These *Freundschaftskarten* were brought by German settlers to the US, and also flourished in Britain. They were handmade, with cut heart and hand motifs, often covered with tiny messages of love.

The first commercial Valentine's cards were created in the 1840s by an American woman, Esther Howland. At the same time, the Penny Post in Britain and the United States Post Office Department led to a huge transformation in communication and the Valentine's craze exploded. Cards were embellished and ornamented with lace and coloured paper, satin and silk. The visual focus was on cupids, pastoral couples, birds and flowers. Copious books were published on what to write in Valentine's cards, with verses ranging from the lewd to the sentimental.

The heart – usually combined with plump cupids – became the Valentine image of choice, particularly after the increase of picture postcards and lithography between 1907 and 1914. The commercial success of Valentine's Day, reinforced by the card industry, can be interpreted as a desire for humanity to express love and emotion.

Left: Gary Taxali,
Love You, 2013.

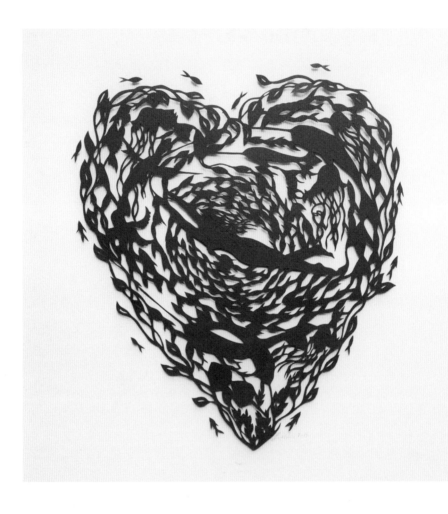

Above: Sarah Dennis, *Swimming Heart*, 2013.

Right: Rob Ryan, *We Had Everything*, 2010.

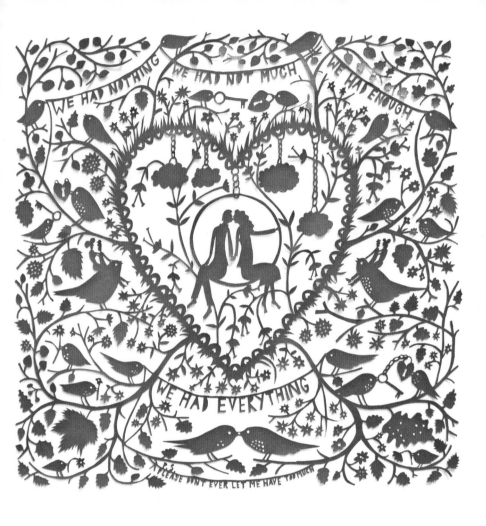

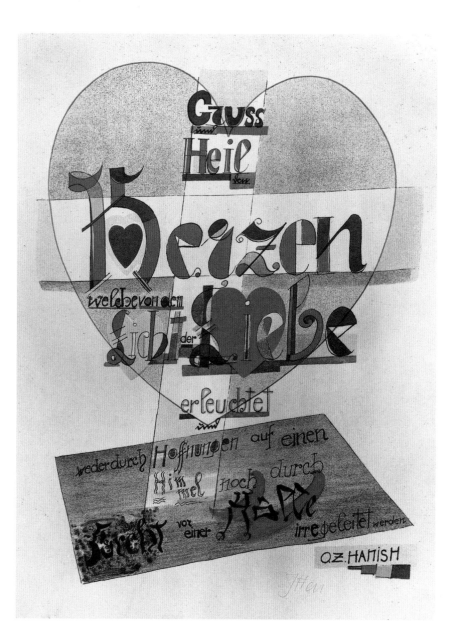

Gruss und Heil den Herzen welche von dem Licht der Liebe erleuchtet weder durch Hoffnungen auf einen Himmel noch durch Furcht vor einer Hölle irregeleitet werden

O.Z. HANISH

120

Left: Johannes Itten, *Saying (Spruch: Gruss und Heil den Herzen, welche von dem Licht der Liebe erleuchtet und weder durch Hoffnungen auf einen Himmel noch durch Furcht vor einer Hölle irregeleitet werden)*, 1922/1923.

Right: Ellen Giggenbach, *Engaged*, 2013. Lagorn Design note card.

Below: Darling Clementine, *Florence the Fox (Be Mine)*, 2012.

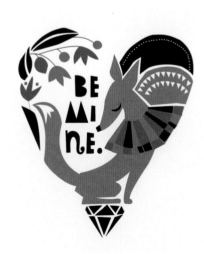

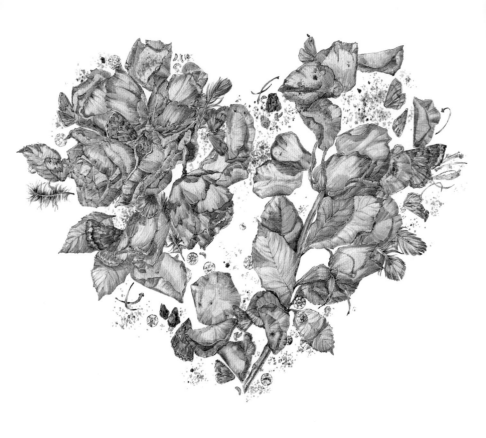

Above: Victoria Foster,
Oh Floral Heart, 2013.

Right: Alessandro
Maffioletti (aka Alvvino),
Heartbeat, 2009.

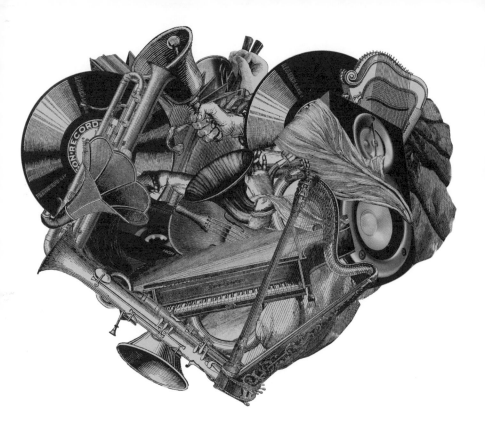

The Organ

Humanity has always been captivated by how the heart works. The ideas of the Roman doctor and philosopher, Galen of Pergamon (129–216 AD), dominated ideas of the heart's role in the body for centuries. Influenced himself by the ancient Greek doctor, Hippocrates, Galen saw the heart as part of a system involving four elements, or humours – blood, yellow bile, phlegm and black bile. These humours had physical attributes, as well as emotional effects.

Dante Alighieri's *Divina Commedia* describes the heart as the location of fear in the body, and a lake, where blood would accumulate as in a ditch. 'Heart' was also Tudor slang for the vagina. People were unaware that the heart is a muscle that pumps blood around the body, believing instead that it pulled in blood. Indeed, a misinterpretation of medical descriptions may have led to the invention of the indented heart shape.

Visual understanding of the heart changed dramatically in the seventeenth century, as the organ was dissected, labelled and examined. English physician William Harvey firmly established how the heart worked in 1628. His book *De Motu Cordis* destroyed the concept of humours in one fell swoop.

Contemporary science has discovered the relationship between the heart and emotions is not just myth. The heart has been shown to play a vital part in the control of hormones and in responses to thoughts and feelings. The heart may be an organ, but there is still metaphor and poetry within its walls.

Right: Howie Tsui,
Dr. Pulmonari, 2013.

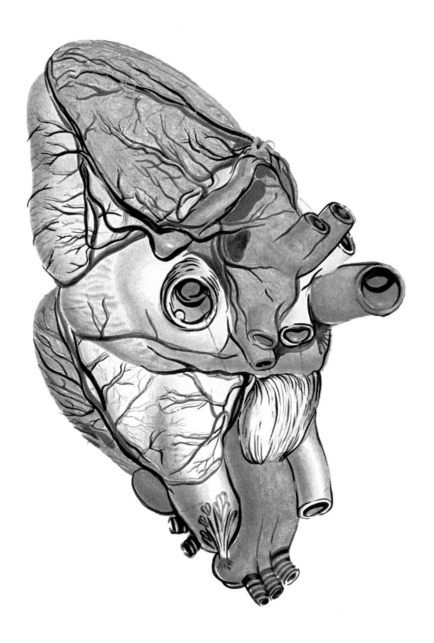

125

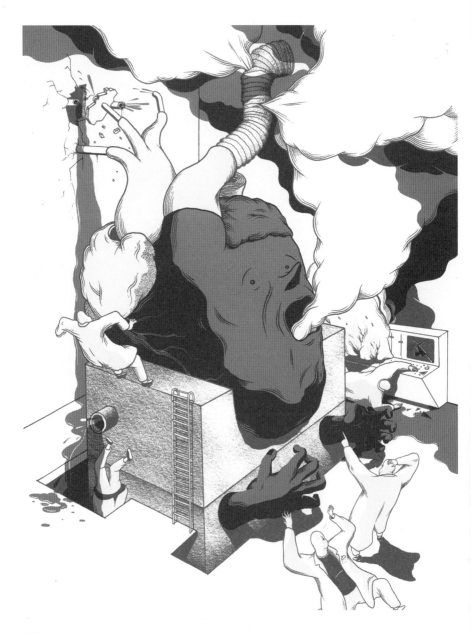

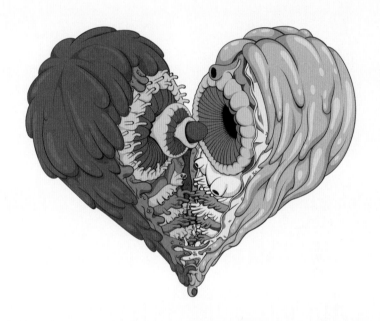

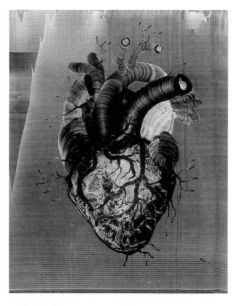

Previous pages (left):
Renaud Vigourt,
Laboratory Accident,
2013.

Previous pages (right):
Alex Trochut,
Heart, 2009.

Left: Matthew Killick,
Heart 1 & 2, 2012.

Right: Diann Bauer,
We are Meat, 2013.

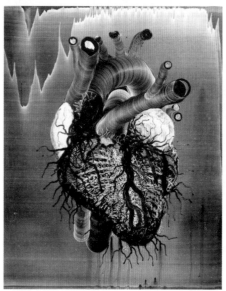

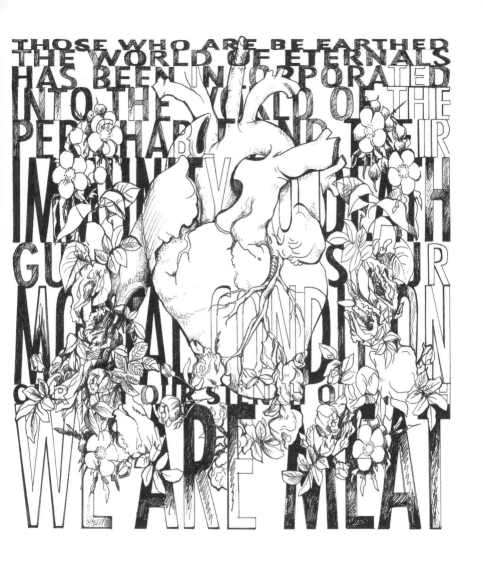

THOSE WHO ARE BE EARTHED
THE WORLD OF ETERNALS
HAS BEEN INCORPORATED
INTO THE WORLD OF THE
PERISHABLE AND THEIR
IMMUNITY DEATH
GUARANTEES OUR
MORTAL CONDITION
CRIP YOUR SIGN TO
WE ARE MEAT

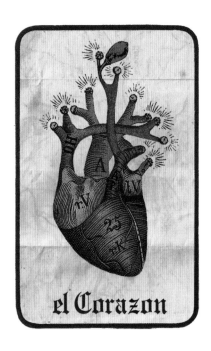

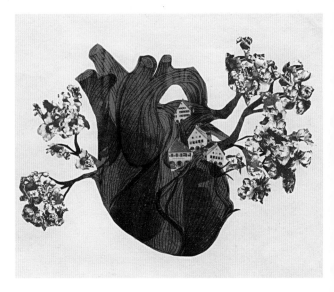

Left: Lynn Hatzius, *El Corazon*, 2009. One of a pack of cards for the traditional Mexican game of Loteria.

Right: Derya Öztürk, *Herzrad*, 2007.

Below: Amy Louise Olszak, *Heart Box*, 2012.

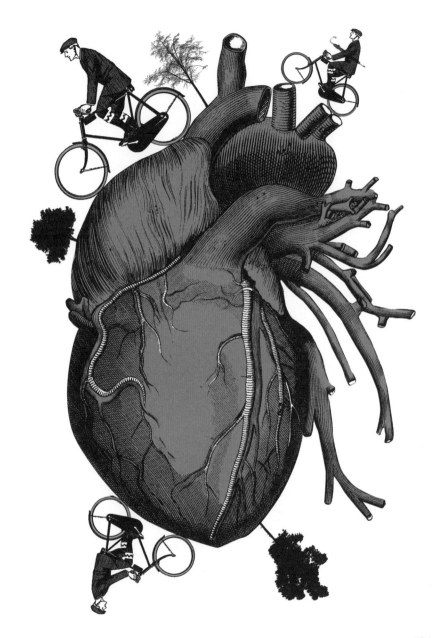

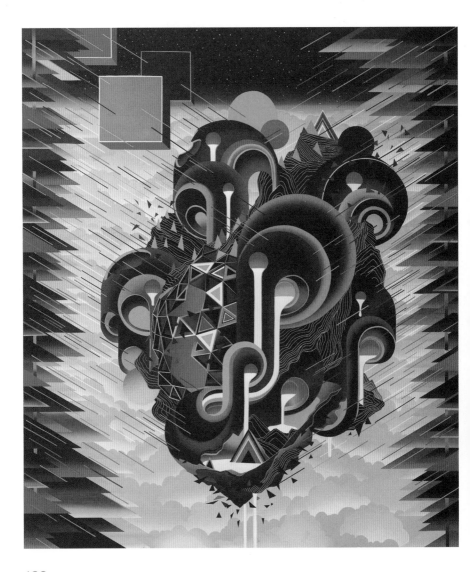

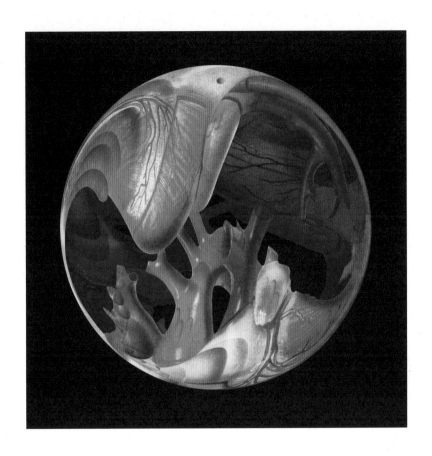

Above: Mario Hugo,
Heart, 2013.

Left: Sam Chivers,
Untitled, 2012.

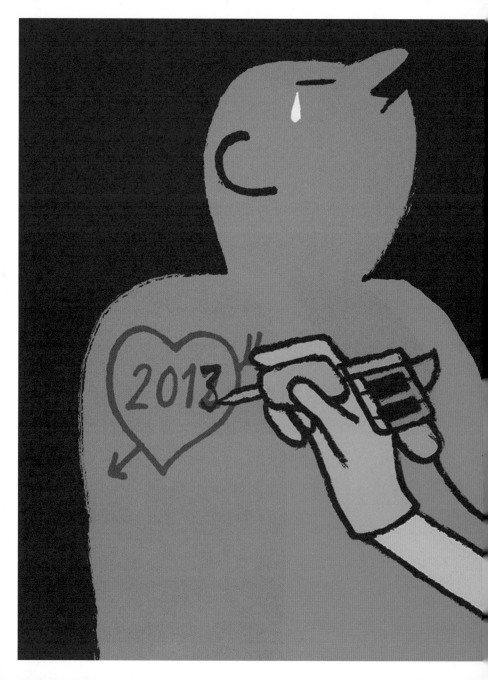

Tattoos

Like heart symbols, the earliest tattoos had a magical and protective significance, and were found on mummies in Egyptian tombs from 4000 to 2000 BC. The ancient practice was prohibited by the Catholic Church and began to disappear after the Norman conquest of England in the eleventh century, although it continued to thrive in Asia.

The word 'tattoo' was introduced by Captain James Cook. It was taken from the word *ta*, the Polynesian verb for 'knock' or 'strike'. Sailors were the first to disseminate tattooing techniques, and the heart was one of the earliest motifs adopted by them, alongside stars, initials and, later, ships, anchors, mermaids and flags. These symbols were meant to ward off storms, shipwrecks, the evil eye, shark attacks, plague and venereal disease.

The peak of tattooing's popularity was in the early 1900s. Even King George V and Czar Nicholas III were tattooed while visiting Japan. After World War I, tastes changed and the practice came to be associated with criminal culture. In 1962, after reports of hepatitis outbreaks and blood poisoning, tattooing was made illegal in some US states, and severely restricted by law in others.

The heart image, however, survived as a strong visual motif in underground tattoo culture. US artist 'Sailor Jerry' Collins created his own aesthetic blend of Western and Japanese tattoo art. His aesthetic is still evident as an influence on many contemporary heart tattoos. In 1950s and 1960s gang culture, heart tattoos were a sign of ownership. One gang tradition was for couples to get matching hearts containing their initials tattooed above their nipples.

Left: Jean Jullien,
Tattoo, 2013.

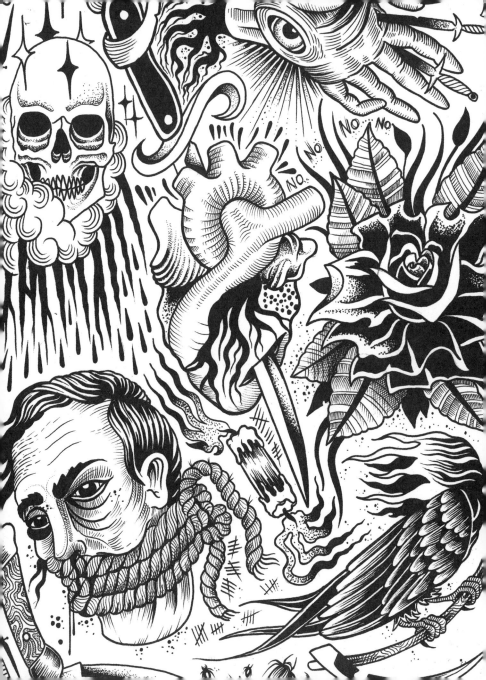

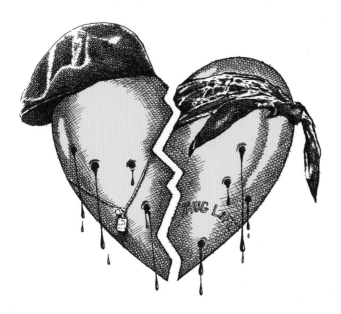

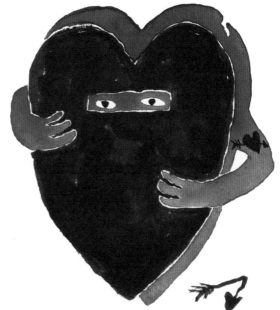

Above: //DIY, *Biggie & Tupac*, 2010. Movie poster, 'Sound and Vision' series.

Left: Scottmove, *No no no no....*, 2013.

Right: Jody Barton, *Falling Love*, 2013.

137

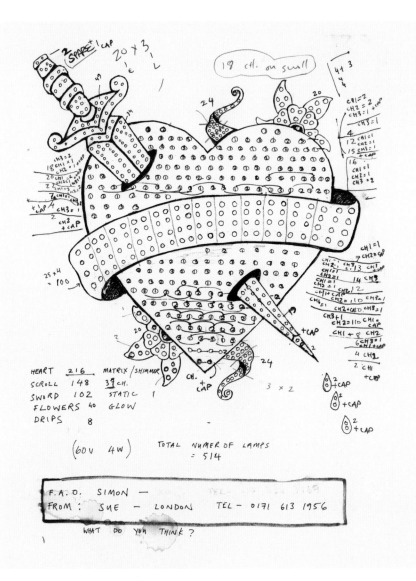

HEART <u>216</u> MATRIX/SHIMMER
SCROLL 148 <u>39</u> CH.
SWORD 102 STATIC 1
FLOWERS 40 GLOW
DRIPS 8

(60V 4W) TOTAL NUMBER OF LAMPS
= 514

F.A.O. SIMON —
FROM: SUE — LONDON TEL - 0171 613 1956

WHAT DO YOU THINK ?

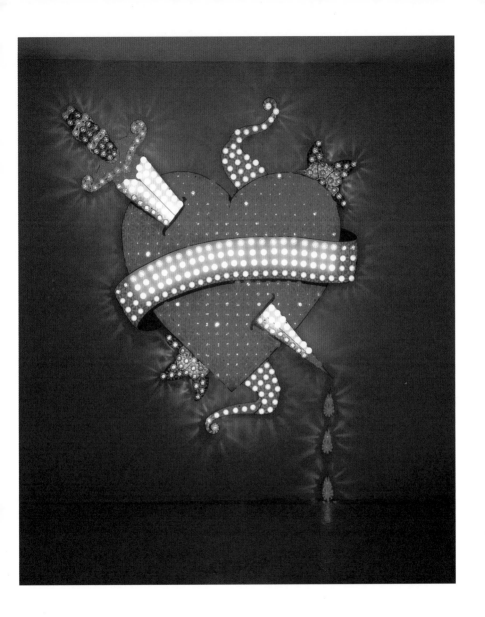

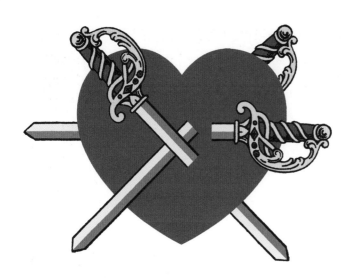

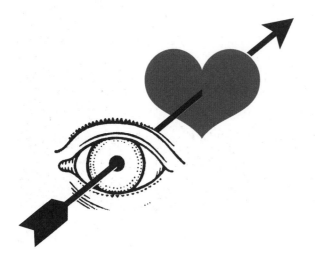

Previous pages (left):
Tim Noble & Sue Webster,
Toxic Schizophrenia
wiring diagram, 1997.

Previous pages (right):
Tim Noble & Sue Webster,
Toxic Schizophrenia, 1997.

Above: Mikel Jaso,
Untitled, 2011.

Left: Mikel Jaso,
Untitled, 2011.

Right: Christian Petersen,
Heartskeleton, from
the fanzine *Love*,
2000–2002.

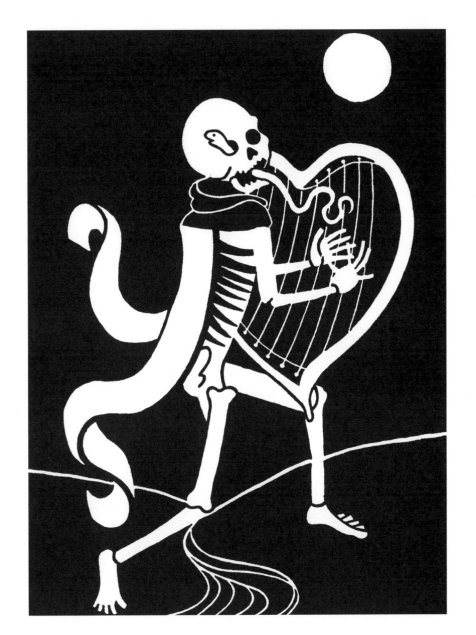

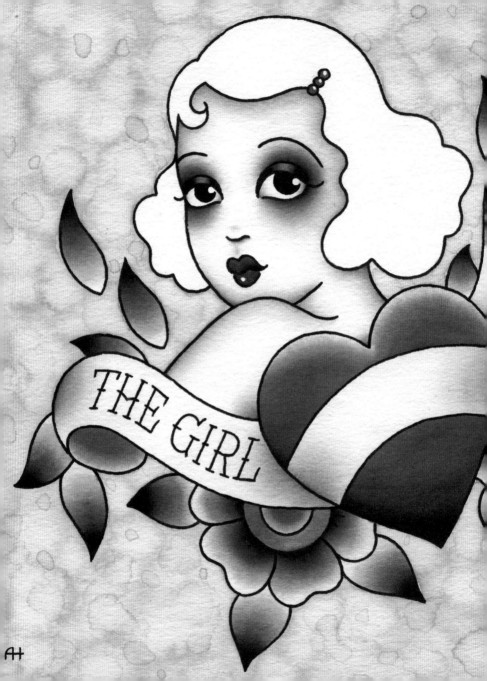

Left: Angelique
Houtkamp, *The Girl
I Love*, 2008.

Below: Angelique
Houtkamp, *You N Me*,
2005.

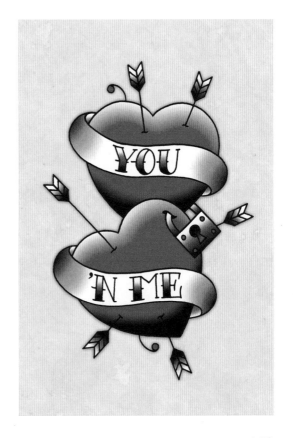

The Gothic Heart

In the past ten years, the representation of the heart as an organ has become increasingly popular. This is undoubtedly connected to the rise of gothic imagery that followed in the wake of September 11, 2001, as well as the rise of tattoo images in mainstream culture. The relationship between the gothic and the heart goes back a long way. Stories of eating hearts recur in ancient Greek, Aztec and Egyptian cultures, and even in early chivalric stories. This gory narrative can still be seen as reflected in the current cliché of eating heart-shaped chocolates.

Edgar Allen Poe's short story 'The Tell-Tale Heart' is a fascinating example of the heart's role in gothic literature. It is written from the point of view of a murderer, who kills an old man, then dismembers and hides the body beneath his bedroom floorboards. He begins to hear an increasingly loud violent heart beating from beneath the floor and, overcome with fear and guilt, confesses his crime.

The heart played an important role in mysticism. It represented the sun in the human body and was vital in alchemical thinking. Alchemy was seen as a demonstration of the desire to purify the heart. The heart was also a magical object. Buried bull and sheep hearts stuck with pins have been discovered all over Britain. A pigeon heart hung above a door was said to bring a lover. A pierced animal heart placed beneath a pillow was thought to invite death. In these darker contexts, the heart became a metaphor for romantic obsession.

Right: *Le Succube,* c. 1870.

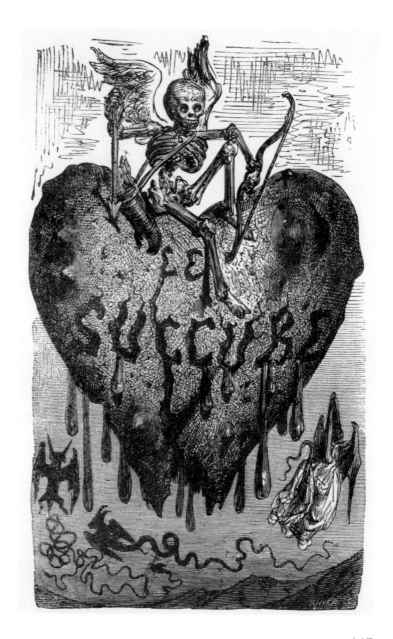

Above: Arthur Rackham,
Telltale Heart, 1842.

Right: Edvard Munch,
The Girl and the Heart,
late 19th / early 20th
century.

Opposite: Aubrey
Beardsley, *The Mirror
of Love*, 1898.

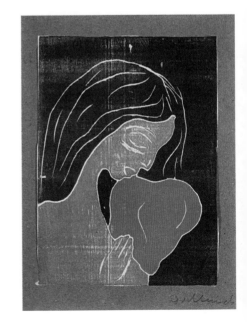

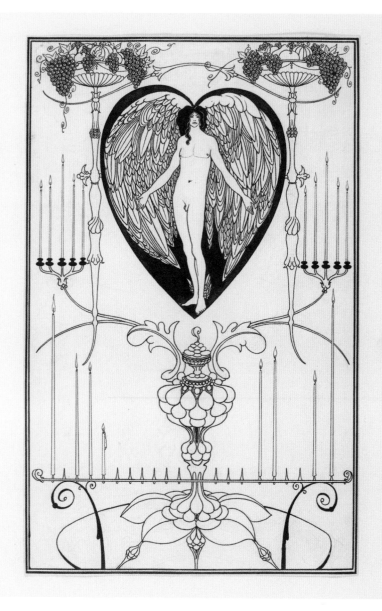

147

Above: Neal Fox,
Heart of Darkness, 2013.

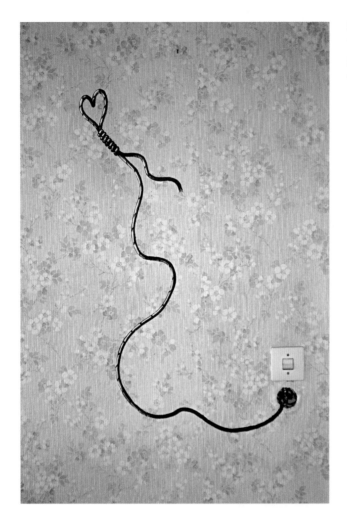

Left: Shok-1, *Heart Noose – East Germany*, 2010.

Right: Dan Hillier, *Aperture*, 2013.

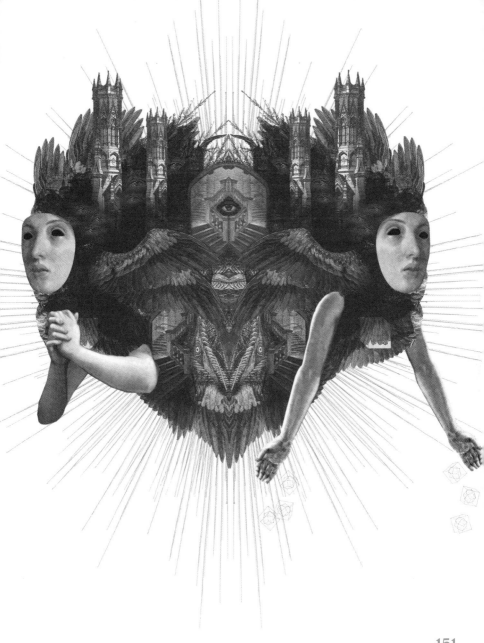

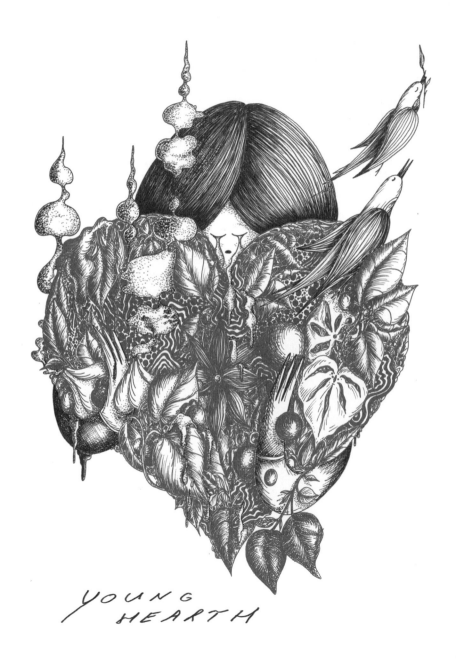

YOUNG
HEARTH

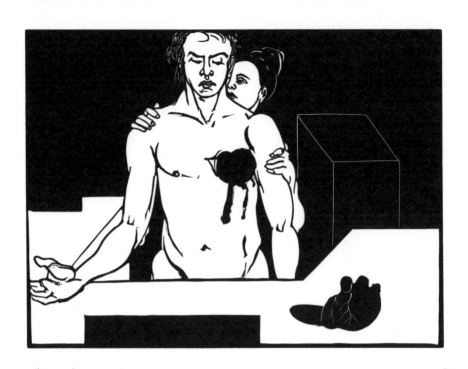

Above: Andrzej
Klimowski, *Small Heart*,
1995.

Left: Merijn Hos, *Young
Hearth*, 2013.

Acknowledgements

To the family Gavin, in particular Seana for her research assistance, and Paola for her incredible sub-editing skills. I'd also like to thank all the artists in the book for their kind inclusions, Donald Dinwiddie, Helen Rochester and Laurence King, Victoria Camlin for St Pancras coffees, and the writing of Louisa Young, Ole Hoystad and Gail Godwin among others on the heart's history. I'd also like to thank the British Library for making the text research one of the most enjoyable experiences of my life – where I learnt that the word 'fascinating' comes from the Latin for erect penis, *fascinus*.

About the Author

Francesca Gavin is the Visual Arts Editor of *Dazed & Confused*, Art Editor of *Twin* magazine and a contributing editor at *Sleek* and *AnOther*. She has written four books, including *100 New Artists* and *Hell Bound: New Gothic Art*. She has also curated a number of exhibitions, including 'The Dark Cube' (Palais de Tokyo, Paris), 'E-Vapor-8' (319 Scholes, NY) and 'The New Psychedelia' (MU, Eindhoven). She is the curator of the Soho House collection and has written for publications including *Vogue*, *wallpaper**, *GQ*, *Time Out*, the *Guardian* online, *Art Review* and the *Sunday Times* Style section.

roughversion.blogspot.com

List of Artists

//DIY diy.li
Aleksandra Mir www.aleksandramir.info
Alessandro Maffioletti aka Alvvino www.alvvino.org
Alex Binnie www.alexbinnie.com
Alex Trochut www.alextrochut.com
Amy Louise Olszak www.amylouiseolszak.com
Andrew Woodhead andrewwoodhead.com
Andrzej Klimowski www.klimowski.com
Angelique Houtkamp www.salonserpent.com
Annie Morris www.anniemorris.com
Antony Micallef www.antonymicallef.com
Antoine et Manuel www.antoineetmanuel.com
Antti Uotila www.anttiuotila.com
Ben Branagan benbranagan.co.uk
Brad Downey braddowney.com
Brett Ryder www.brettryder.co.uk
Brian Roettinger brianroettinger.com
Cécile B. Evans cecilebevans.com
Chris Bianchi www.chrisbianchi.co.uk
Chris Bourke chrisbourkeart.com
Chris Uphues chrisuphues.com
Christian Petersen www.iwantyoustudio.com
Craig & Karl www.craigandkarl.com
Craig Robson daggersforteeth.tumblr.com
Dan Hillier www.danhillier.com
Darling Clementine www.darlingclementine.no
David Godbold www.weingruell.com
David Sandlin davidsandlin.com
David Saunders daviddavid.co.uk
David Spiller www.davidspiller.co.uk
Derya Öztürk www.yader.com
Diann Bauer diannbauer.net
Donald Urquhart maureenpaley.com
Duane Dalton duanedalton.com
Ellen Giggenbach www.ellengiggenbach.com
Emily Forgot www.emilyforgot.co.uk
Emma Rendel www.emmarendel.com
FriendsWithYou friendswithyou.com

Gary Baseman www.garybaseman.com
Gary Taxali www.garytaxali.com
Geneviève Gauckler www.genevievegauckler.com
Hellicar & Lewis www.hellicarandlewis.com
Howie Tsui www.howietsui.com
Hudson Powell www.hudson-powell.com
Hvass + Hannibal www.hvasshannibal.dk
Ian James Marshall ianjamesmarshall.com
Izzie Klingels www.izzieklingels.com
Jacob Ciocci jacobciocci.org
James Joyce jamesjoyce.co.uk
Jamie Cullen jamiecullen.net
Javier Rodriguez Garcia www.lobulodesign.com
Jean Jullien www.jeanjullien.com
Jimmy Turrell www.jimmyturrell.com
Jody Barton www.jodybarton.co.uk
Jonathan Zawada zawada.com.au
Julie Verhoeven www.julieverhoeven.com
Junko Mizuno www.mizuno-junko.com
Kate Moross www.katemoross.com
Kaws www.kawsone.com
Keegan McHargue keeganmchargue.com
Keith Haring www.haring.com
Kenji Hirata www.kenjihirata.com
Luke Ramsey lukeramseystudio.com
Lynn Hatzius www.lynnhatzius.com
Marco Wagner www.marcowagner.net
Mario Hugo mariohugo.com
Marta Cerdà Alimbau www.martacerda.com
Matthew Killick www.matthewkillick.co.uk
Matthew Murphy matthewmurphy.biz
Maya Hayuk mayahayuk.blogspot.com
Maya Wild mayawild.com
Merijn Hos merijnhos.com
Mikel Jaso www.mikeljaso.com
Neal Fox www.nealfox.co.uk
Nigel Payne www.nigelpayne.com
Noma Bar nomabar.com
Patrick Thomas www.patrickthomas.com
Patternity www.patternity.co.uk

Paul McDevitt www.stephenfriedman.com
Randy Mora www.randymora.com
Renaud Vigourt www.renovigo.com
Rina Donnersmarck www.rinadonnersmarck.blogspot.co.uk
Rob Ryan www.misterrob.co.uk
Robert Rubbish robertrubbish.blogspot.com
RWO Stone rwostone.com
Sam Chivers www.samchivers.com
Sarah Dennis sarah-dennis.co.uk
Saya Woolfalk www.sayawoolfalk.com
Scott Campbell scottcampbellstudio.com
Scottmove scottmove.co.uk
Sean Morris www.illsean.com
Seana Gavin seanagavinart.tumblr.com
Shok-1 www.shok1.com
Steph von Reiswitz www.stephvonreiswitz.com
Stephan Doitschinoff aka Calma doitschinoff.com
Théo Gennitsakis www.theogennitsakis.com
Tim Lahan www.timlahan.com
Tim Noble & Sue Webster www.timnobleandsuewebster.com
Victoria Foster www.the-aviary.co.uk
Wolfe von Lenkiewicz wolfevonlenkiewicz.com
Yehrin Tong www.yehrintong.com
Yinka Shonibare www.yinkashonibarembe.com
Zakee Shariff www.zakeeshariff.com

Picture Credits

2–3 drawn by Sean Morris; 6 © 2013 Patrick Thomas; 8 Brian Roettinger, courtesy the artist; 13 © Gary Taxali ALL RIGHTS RESERVED; 22 © Duane Dalton; 29 Courtesy of Stephen Friedman Gallery, London and Sommer & Kohl, Berlin; 36 © Junko Mizuno; 37 © Stephanie von Reiswitz; 40–41 Regensburg, Germany. Inv. 467–1908, Photo: Joerg P. Anders. Photo Scala, Florence/BPK, Bildagentur für Kunst, Kultur und Geschichte, Berlin; 42 Oil and charcoal on canvas, 140 x 140 cm, courtesy Antony Micallef; 43 Four colour lithographic print together with silk screen, collaged Dutch-wax fabrics and 23-carat gold leaf, 65 x 47 cm. Edition of 25, courtesy Yinka Shonibare; 45 Snark/Art Resource, NY; 46 Lithograph with watercolour additions, 20 x 15 cm. Museum of Modern Art, New York, Digital image, The Museum of Modern Art, New York/Scala, Florence; 49 David Sandlin, courtesy of the artist; 50 (left) Private collection; 50 (right) David Godbold, © courtesy of the artist; 61 ©Tim Lahan, 2013; 64–65 Rob Ryan, courtesy of the artist; 70 Photo: Volker-H. Schneider, Photo Scala, Florence/BPK, Bildagentur für Kunst, Kultur und Geschichte, Berlin; 72 INTERFOTO/TV-yesterday/Mary Evans; 76–77 © Craig Robson/DaggersforTeeth; 80 (bottom) Donald Urquhart, © the artist, courtesy Maureen Paley, London; 84–85 David Sandlin, courtesy of the artist; 90 Saya Woodfalk, courtesy of the artist; 94, 97 (bottom), 102 (top), 103 Samuel Borkson and Arturo Sandoval for FriendsWithYou, 99–100 Design by Jacob Ciocci, Written by Becky Stark & Peter Glantz, see prints and cartoons at imaginarycompany.org/worldword; 106 David Saunders, creative director at David David; 108–109 Tim Noble & Sue Webster, courtesy of the artists; 116 © Gary Taxali ALL RIGHTS RESERVED; 119 Rob Ryan, Courtesy of the artist; 120 Photo: Klaus G. Beyer, © DACS 2014, Photo Scala/BPK, Bildagentur für Kunst, Kultur und Geschichte, Berlin; 121 (bottom) Ingrid Reithang/Tonje Holand, courtesy of the artists; 123 Designed by alvvino – www.alvvino.org, Project Manager: Lorenzo Pilia www.tiif.it, Client: Aupeo - www.aupeo.com; 125 Howie Tsui, Courtesy of the artist; 126 Renaud Vigourt, Courtesy of the artist; 127 Client: Beautiful Decay; 133 © Mario Hugo; 138–139 Tim Noble & Sue Webster, courtesy of the artists, Photographer: Peter Thuring; 145 Mary Evans Picture Library; 146 (top) Mary Evans Picture Library/ARTHUR RACKHAM; 146 (bottom) © The Munch Museum/The Munch Ellingsen Group, BONO, Oslo/DACS, London 2014, Photo Scala, Florence; 147 © Victoria and Albert Museum. London; 159 © The Israel Museum, Jerusalem, Israel/Vera & Arturo Schwarz Collection of Dada and Surrealist Art/The Bridgeman Art Library, Succession Marcel Duchamp/ADAGP, Paris and DACS, London 2014.

Right: Marcel Duchamp, *Fluttering Hearts*, 1936/1968.

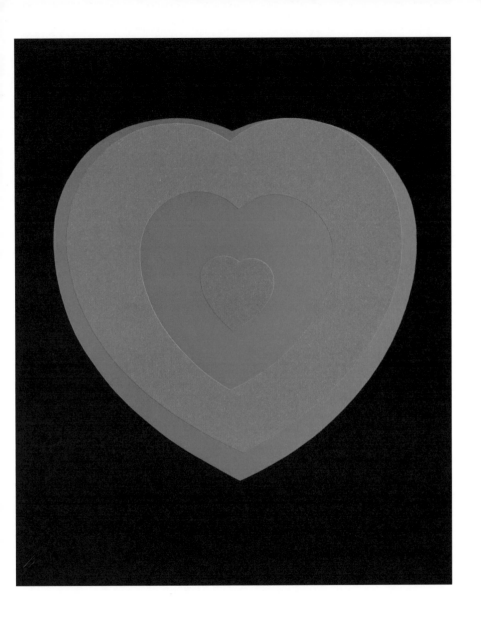

LAURENCE KING

Published in 2014 by
Laurence King Publishing Ltd
361–373 City Road
London EC1V 1LR
Tel: +44 20 7841 6900
Fax: +44 20 7841 6910
email: enquiries@laurenceking.com
www.laurenceking.com

A catalogue record for this book is available
from the British Library.

ISBN 13 : 978 1 78067 331 8

Design: Praline
Cover artwork: Angelique Houtkamp

Printed in China

'If I can stop one heart from breaking, I shall not live in vain.'

Emily Dickinson